vanishing
borderlands

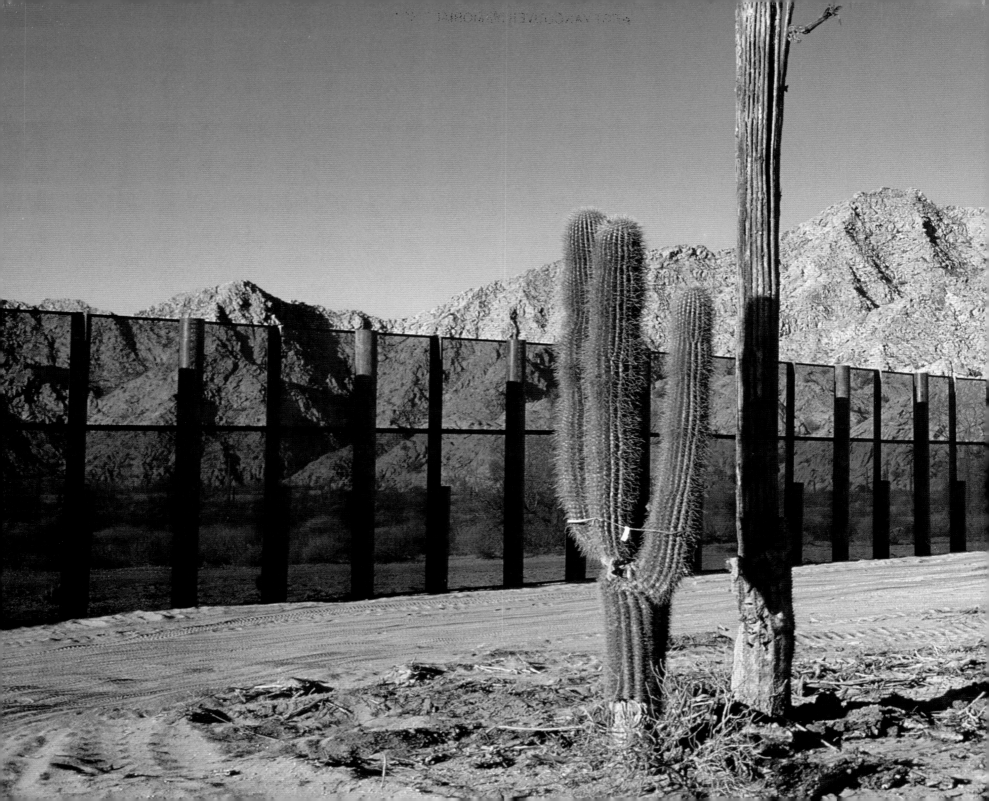

vanishing borderlands

The Fragile Landscape of the U.S.–Mexico Border

John Annerino

THE COUNTRYMAN PRESS
WOODSTOCK, VERMONT

Para mi vida y mi amor, Alejandrina

First Edition

Annerino, John.
Vanishing borderlands : the fragile landscape of the U.S.–Mexico border / John Annerino. — 1st ed.
 p. cm.
 Includes bibliographical references.
 ISBN 978-0-88150-717-1
 1. Mexican-American Border Region—Pictorial works. 2. Landscape—Mexican-American Border Region—Pictorial works. 3. Immigrants—Mexican-American Border Region—Pictorial works. 4. Drug traffic—Mexican-American Border Region—Pictorial works. 5. Mexican-American Border Region—Environmental conditions—Pictorial works. I. Title.

F787.A67 2008
972'.10830222—dc22 2008006747

Book design and composition by Eugenie S. Delaney
Cartography by Jacques Chazaud

Published by The Countryman Press, P.O. Box 748, Woodstock, VT 05091
Distributed by W. W. Norton & Company, Inc., 500 Fifth Avenue, New York, NY 10110

Printed in China

10 9 8 7 6 5 4 3 2 1

PREVIOUS PAGE: *The Wall, United States–Mexico border, Arizona. Under the Real I.D. Act, the Department of Homeland Security waived environmental laws to build a $20 million, 37-mile barrier on the southern border of the Barry M. Goldwater Range. Construction left a heavy "footprint" on the fragile landscape: Impenetrable to wildlife, the wall may prove devastating for animals that have historically migrated during drought, including an estimated 250 desert bighorn sheep* (Ovis canadensis mexicana) *and 100 endangered Sonoran pronghorn antelope* (Antilocapra americana sonorensis).

RIGHT: *Cerro Colorado Crater, Reserva de la Biosfera de El Pinacate and UNESCO World MAB Reserve, Sonora, México.*

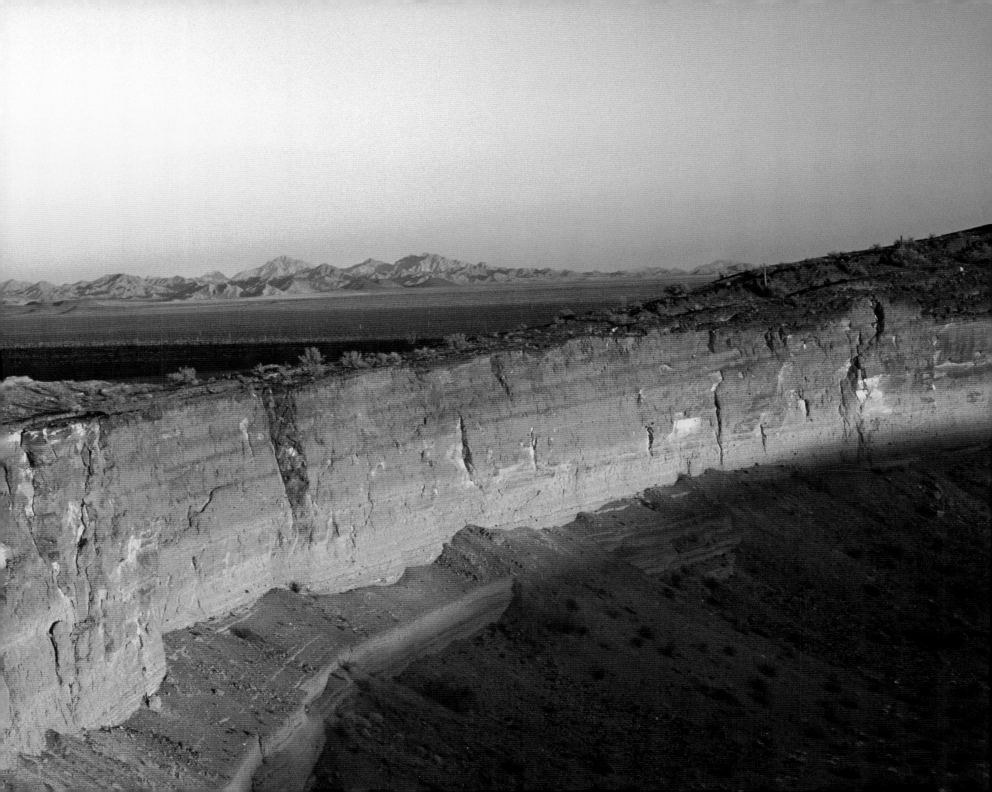

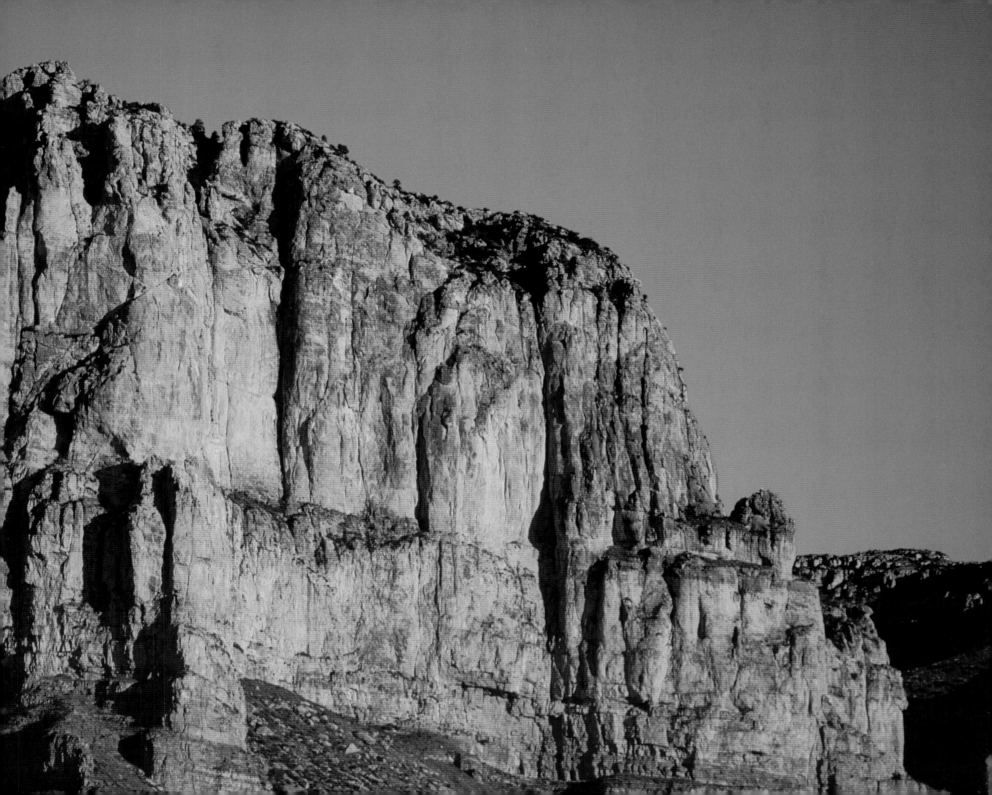

acknowledgments

OVER THE YEARS I'VE HAD THE PRIVILEGE TO WORK ON THE BORDER FOR MANY FINE EDITORS. I want to thank Burt Rudman, Producer, *ABC News Primetime*; Kim Shannon, Photography Director, *America 24/7*; Stephanie Robertson, Perspective Editor, *The Arizona Republic*; John G. H. Oakes, Editor, *Four Walls Eight Windows*; Jennifer B. Coley, Director, Liaison International photo agency; Peter Howe, Picture Editor, *LIFE*; John Rasmus, Editor in Chief and Steve Byers, Editor, *National Geographic Adventure*; Guy Cooper, Picture Editor, *Newsweek*; Russell Sparkman, Director, *One World Journeys*; Richard S. Vonier, Editor, *Phoenix Magazine*; and Patricia Lantis, Director, Time Inc. *TimePix* photo agency.

I'd especially like to thank *LIFE* Picture Editor Melvin L. Scott, who had the confidence to send a fledgling photojournalist to the Big Bend frontier on my first border assignment years ago.

I'm grateful to the trustworthy companions who accompanied me on oftentimes perilous borderland journeys, including naturalist Bill Broyles, author Tim Cahill, Outward Bound leader Cecilia McClung, *Camino del Diablo* companions Bruce Lohman and David Roberson, and my family, who relished the borderlands' natural wonders before they became too dangerous for them to explore.

Jon Young, Law Enforcement Ranger, Bureau of Land Management; Roger DiRosa, Refuge Manager, Cabeza Prieta National Wildlife Refuge; Brian Cook, U.S. Customs and Border Protection Blackhawk Pilot and Aviation Supervisor; and Joseph Parra Berumi, retired Interpol agent, opened my eyes to the chaos and risks still faced in the borderlands each day.

Many of the good people I met in Mexico's borderlands invited me into their adobes homes to share wood-fire cooked meals, colorful stories, and a way of life long forgotten in the United States. In Nuevo León, Alfredo Gómez-Martínez and Jesús Contreras-Hernández; in Coahuila, the Silvia Ureste family and Victor Váldez; in Chihuahua, Margarita Quintero de González, Antonio González-Ortíz, and the Ángel Fierro-Gill family; in Sonora, Eugenio Velasco-Ortega, Herlinda León-Pacheco, and the Nora and Aurelia Molino family. Farther south in Guanajuato, loving mother Natalia Sierra-Páramo, and friend photographer Julio Reza-Díaz, introduced me to the people, food, traditions, and colonial silver cities that lead north from Mexico City to the border along *El Camino Real de Tierra Interna*. Closer to home, *Hia Ced Ó'odham* elder Chico Shunie opened his door to me after rangers insisted he lived on "their" land, and María García invited me to photograph the Miguel Ángel Grijalva mural of La Virgen de Guadalupe on the wall of her *tienda*.

You would not be holding this book in your hands without the stunning design of Eugenie S. Delaney and the collaborative talents of Theresa Ebarb, Tony Ebarb, Donald H. Bayles, Jr., Deb Goodman, Dale Evva Gelfand, Jacques Chazaud, Julie Nelson, Jennifer Thompson, Kermit Hummel, and Bill Rusin.

Thank you.

contents

crossing the line

> The overriding image at dusk was of shadow.
> Looming shadow, fleeting shadow . . . scorpions and tarantulas. . . .
> Wind rattled the dry brush. Every rattle was spooky because of snakes.
>
> —JOSEPH WAMBAUGH
> *LINES AND SHADOWS*, 1984

THE BLACK BAJADAS SWEPT OUT FROM THE ANGRY FLANKS OF THE DARK PEAK. Taut strands of barbed wire neatly divided the rocky landscape. It did not keep out the scorpions, tarantulas, and coyotes, which traveled freely through the wires that sang in the wind under the cover of night. Nor did it keep the curious at bay. Beckoned by promises of what lay beyond, the four of us crossed the line, squeezing between rusty barbs that tore at our clothing and sun-browned skin.

The gravel veneer of desert pavement stretched before us, glistening in our eyes as we strode west toward the yellow sun. A soft desert breeze caressed the creosote, and the skeletal limbs of ocotillo swayed around saguaro that towered overhead. They were green and fat, gorged with water from summer monsoons. It was September. The desert had cooled since my eleven-year-old son and I had discovered a miner's camp out here in the August heat, so I hadn't given any thought to rattlesnakes on such a wonderful day. But for some reason, I carried my four-year-old son on my shoulders as we walked through a golden desert that lured us deeper into its embrace.

My wife and sons searched the ground for lost clues of treasure seekers they hoped to see. I searched the horizon for a *bosque* of mesquite trees that marked a secret water hole I hoped to find. Discovered by Captain Juan Bautista de Anza, the mysterious waters of *Aquituni* soothed the parched lips of his caravan of 240 Spanish settlers and 1,000 head of livestock during an epic colonizing expedition from the Presidio de Tubac, Sonora (now

PREVIOUS PAGE: *Picacho Peak, Ninety Mile Desert, Arizona.*

OPPOSITE: *A young cowboy composes himself after a close brush with a tiger rattlesnake* (Crotalus tigris) *in the Ninety Mile Desert.*

Arizona), to the Presidio de Monte Rey, California in 1775–1776. Anza keyed off the landmark volcanic peaks at our backs, as did other brave souls who ventured across the deadly *jornada* (that part of a desert journey without water) between the Presidio de Tucson and the Gila River "For God, for glory and for gold." They included missionary explorer Padre Eusebio Francisco Kino, who traversed the frontier of *Nueva España*, "New Spain," in quest of souls and an overland passage to California in 1699, and the United States and Mexico Boundary Survey, which had the formidable task of drawing a straight line through the border's "geography of chaos" between 1851 and 1857. Now seen by thousands of motorists and truckers who hurtle across their paved-over wagon ruts each day, Picacho Peak had become a landmark for me, as well. It offered refuge from the border's blood-stained ground.

Years earlier I'd moved from my mountain cabin outside Prescott, Arizona, to the sleepy *Pueblo Viejo,* "Old Pueblo,"of Tucson in hopes the change of scenery would be a blessing and not a curse. My natural perceptions were shaped by the piñon and juniper studded slick rock and rivers of the Colorado Plateau, where I worked as wilderness guide and white-water boatman. So I didn't anticipate how the natural landscape of southern Arizona's borderlands and my world view would change before my eyes as I witnessed, photographed, and reported on the "largest human migration on earth" sweeping across the United States–Mexico border.

This exodus was rooted in historic colonizing expeditions begun by Spaniard Juan de Oñate; he led four hundred settlers and seven thousand head of livestock from Mexico City to New Mexico in 1598. The Spanish *entradas* of Oñate, Anza, and others established thriving presidios, haciendas, and pueblos throughout New Spain, which became San Antonio, El Paso, Sante Fé, Tucson, San Diego, Los Angeles, Santa Barbara, and San Francisco long before the United States waged war against Mexico in 1846, made peace with the Treaty of Guadalupe Hidalgo in 1848, and bought the contested ground with the Gadsden Purchase in 1854.

Modern immigrants followed the historic trails forged by Spaniards and Forty-Niners to those bustling cities, but thousands sacrificed their lives in search of the American dream. The porous borderline also had attracted a sophisticated and ruthless cadre of heavily armed drug smugglers, *coyotes* (human traffickers), and *bajadores* (border bandits, kidnappers, and take-down crews), that were unfathomable when Padre Kino and the Jesuits Christian-

ized "heathen" souls in the 1700s. The wanton destruction, refuse, and bodies that fell in the borderlands' celebrated landscapes became difficult to ignore. As did the chilling body count: Some 4,100 known people have perished while crossing the border since Operation Gatekeeper began in 1994; 420 women and girls have been raped and murdered in Ciudad Juárez since 1993 and 700 others have vanished, thirty to sixty Americans among them. Dozens of Customs, Border Patrol, and National Park Service agents were gunned down, run over, and stoned to death in cold blood during the same period. Since 1997, 231 armed incursions were reportedly made by Mexican Federales into the United States. In 2007, twelve people were shot dead by smugglers within a thirty-mile radius of Sonoran desert parklands encircling Tucson. Indigenous lands, cultural resources, wildlife habitat, and endangered species that form our nation's crown jewels of borderlands parks stood in the line of fire. Many suddenly bore the disturbing acronym HIDTA: High-Intensity Drug Trafficking Areas. The 2006 Secure Fence Act's $2.24 billion, 698-mile wall was green-lighted to hold back the tsunami. But some had their doubts from the beginning. After moving to Tucson, I asked one overworked SWAT commander how bad the situation was. He shook his head and said, "Johnny, we're barely holding the line. The genie's out of the bottle—and there's no putting it back in."

His words hit the mark years later while I was covering the murder of National Park Ranger

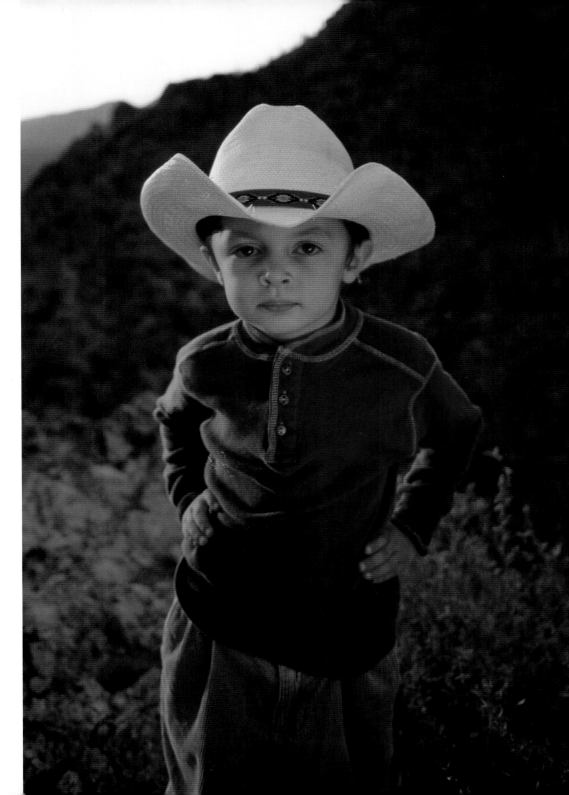

Kris Eggle. He had been gunned down in Arizona's Organ Pipe Cactus National Monument—a UNESCO World Biosphere Reserve—in 2002. Park Ranger Jon Young showed me the murder scene of his friend, which I found deeply troubling. I used to run in Organ Pipe before the border wars hit, and one of my favorite running trails was the *Camino de Dos Republicas* along the Mexican border. I learned it was also one of Eggle's favorites—before he bled to death within sight of it a hundred yards north of the border. Much of the barbed-wire fence that hinted at a border at the time had been removed by locals in Sonoyta, Sonora, to fence off their front yards and gardens.

Jon Young transferred to the Bureau of Land Management as a Law Enforcement Ranger after Eggle's murder, and I accompanied him on patrol of Sonoran Desert National Monument's smuggling corridors to see how the border had been pushed 80 miles north to Interstate 8. Dressed in a Kevlar vest and saddled with an AR-15 assault rifle, Jon turned to me one morning and said: "If I go down, the body armor's on the back seat. Here's how you unclip the AR-15." That scenario played out again months later when I photographed back-to-back border missions of U.S. Customs Blackhawk helicopter crews. "If we go down," one of the pilots showed me, "here's how you call for help." Armed with a camera and pen, I'd never considered before then that I might be "the last man standing."

That was the tipping point for me because I finally realized that everyone on both sides of the line was armed to the teeth. A deadly array of military grade weapons and munitions — and rocks—had replaced the 7mm bolt action Mauser rifles, 30-30 lever-action Winchester carbines, and crisscrossed cartridge bandoliers favored during Francisco "Pancho" Villa's border reign. Villa's revolutionary *corrido* (folk song) to his beloved Winchester 94 *Carabina 30-30* also had been replaced by *corridos* to *Cuernos de Chivo,* the AK-47 that murdered Kris Eggle. The landscape indeed had changed. I needed a respite from the dark realities of the border and how the issues were being ignored, portrayed, and spun by politicians and news anchors on network television. My mailman, a Bosnia special forces veteran, offered cold comfort when I expressed my dismay at American vigilantes hunting Mexican immigrants I had always considered our neighbors: "John, the news gets out, but the truth doesn't."

Picacho Peak offered a refuge from the chaos and a safe haven for my family to explore.

We crossed a shallow arroyo, then climbed back up on the bajadas that swept toward the setting sun in what looked like great brush strokes of volcanic ink dappled green

OPPOSITE: *Spanish Land Grant, San Ignacio del Babocomari, Arizona. Horses graze in grasslands partitioned out by the Spanish crown as land grants to settlers of* Nueva España, *"New Spain."*

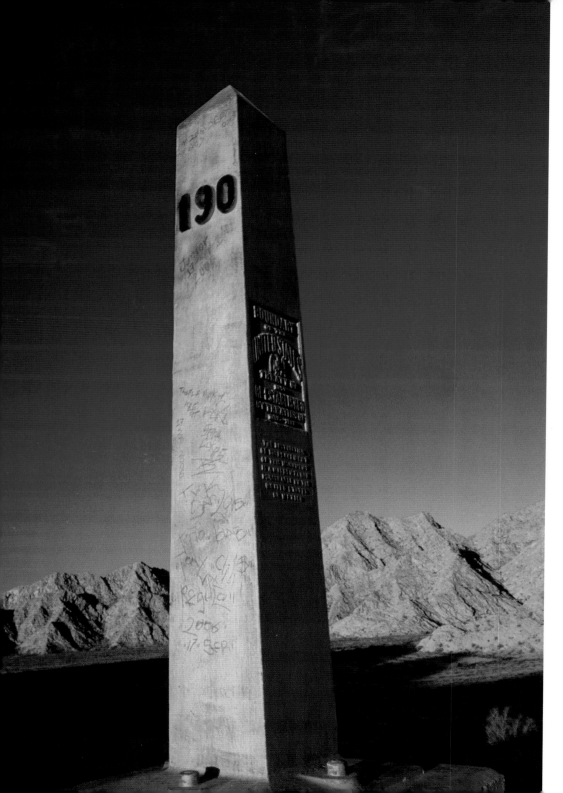

with palo verde and mesquite trees. Broken pot shards littered the desert pavement, scattered around a small fire ring near the rim of a deep arroyo. We stopped to examine the ancient Hohokam encampment, and imagined what it may have been like to try eking a living from the desert floor. We were suspended in time as the sun fell deeper into the crimson horizon. The copper glow bathed the ironwood, saguaro, and cholla cactus with whimsical light. I lifted my younger son off my shoulders and told him to stay with his mom and brother so I could take a photograph.

The light was perfect, but the composition wasn't there. So I picked up my camera bag and tripod I'd placed next to a brittlebush and looked for another vantage nearby. I called my young son over so I could carry him—he liked to pretend I was his horse and spurred my chest with his small cowboy boots. He started running the fifty feet of open ground between us, then suddenly stopped near the bush. He backed away screaming. He was a happy, tough little boy who wanted to be a "big guy" like his older brother, and he rarely screamed. But now his voice was absolute terror. Before I could react, a black snake lifted its head and writhed toward his small legs. In the blink of an eye, his mom swept him up in her arms and held him over head as the tiger rattlesnake slithered away between her feet. We ran toward each other, fearing the worst. Our young son cried, "Oh God, oh God! I don't want to die!" I pulled out my cell phone to see if I had service. I did. But it would take a

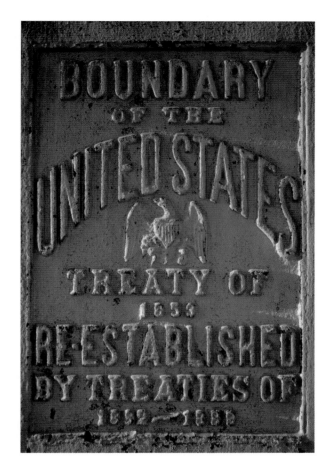

Life Net helicopter 40 minutes to reach us—if one was available. If my son had been bitten and envenomated, there was a good chance he wouldn't make it. He was too small. My older son instinctively pulled the snake bite kit out of his pack. Tears fell down his cheeks when he looked me in the eyes and said, "Dad, I don't want him to die." He handed me a suction extractor, designed to remove snake venom without making an incision. My younger son sobbed, "Daddy, I don't want to die." My wife cradled him as he trembled and whimpered for his life. "You'll be all right, son," I said. I peeled off his blue jeans and looked for the red fang marks I knew had punctured one of his small legs. But there weren't any. We pulled off his boots, socks, and shirt and saw that Mom had somehow been faster on the draw than a black pit viper.

We thanked God, hugged our older son, dressed our little cowboy, saddled him up, and strode back toward the dark peaks that loomed above, silhouetted against the black sky. We walked briskly between fleeting shadows of saguaro that danced around us. But the wind rattled the dry brush, spooking my family until we crossed the wire.

Our family outing inspired me in part to photograph and write a book about such places. Natural worlds of beauty that still offer refuge from the chaos, solace from the crowds, and doses of natural danger to ward against those of armed men. But I was no longer convinced such places still existed in the borderlands' new geography of man-made chaos. The Colorado Plateau had been calling me home of late, and before I packed up my family and moved them out of the war zone, I wanted to go see for myself. And that became my simple but daunting quest: Trace the 1,956-mile United States–Mexico border east

OPPOSITE: *Border Monument, Barry M. Goldwater Range, Arizona. The Secure Fence Act's 698 miles of double-mesh steel walls, Normandy-style vehicle barriers, and virtual fencing, (80-foot towers topped with infrared cameras) will replace historic boundary monuments* (LEFT) *that mark the 1,956-mile border between the United States and the Republic of Mexico.*

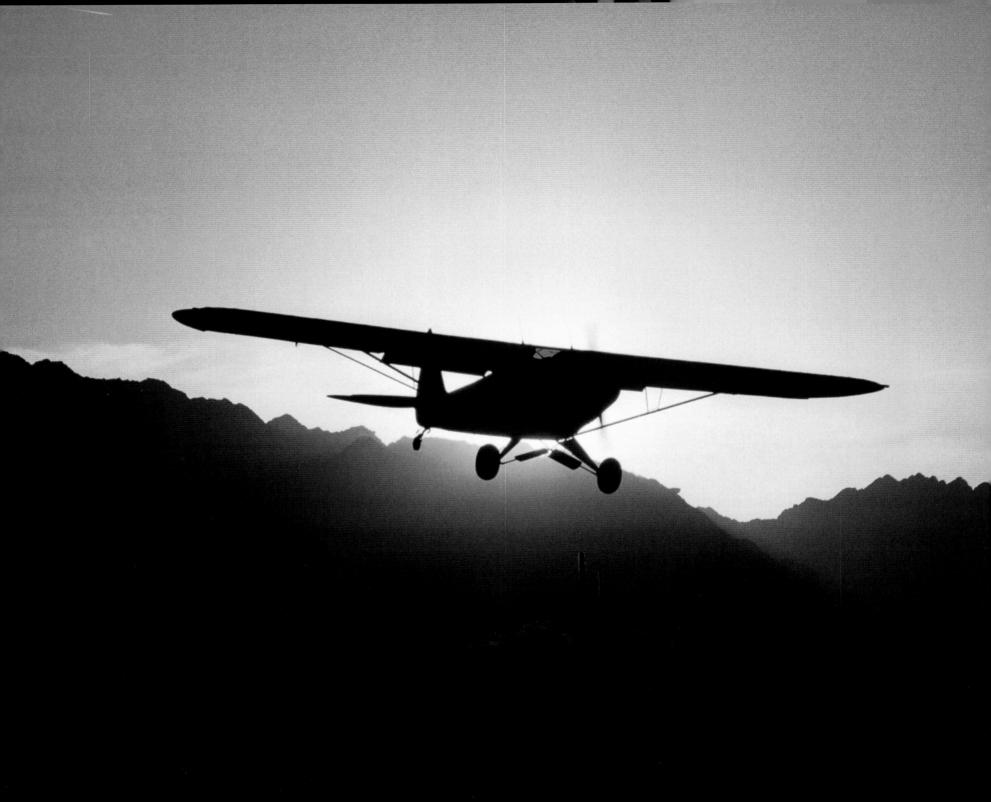

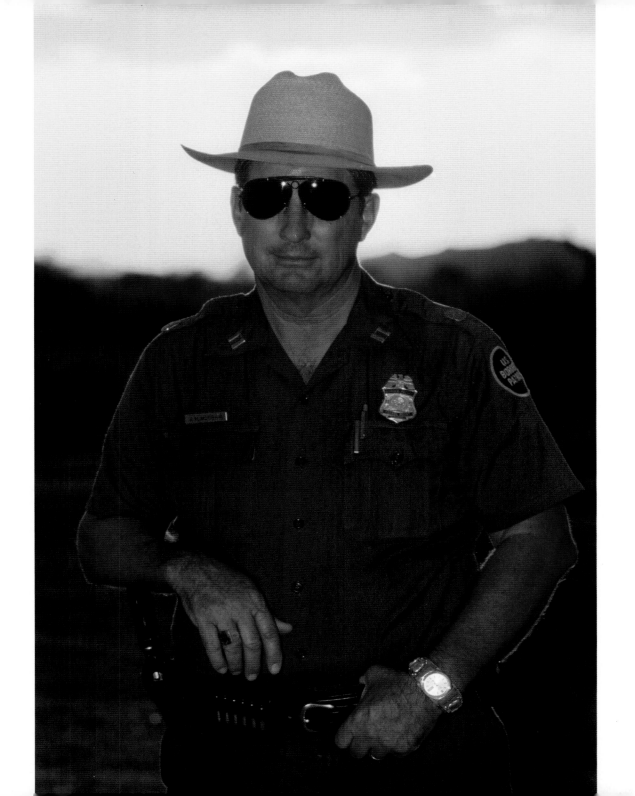

OPPOSITE: *Cutting Sign, Camino del Diablo, Arizona. Tracking from the air, Border Patrol pilot David Roberson and agent Joe McCraw* (LEFT) *grew to love the haunting beauty and rewards of saving people in the treacherous desert of* El Camino del Diablo, *"The Highway of the Devil."*

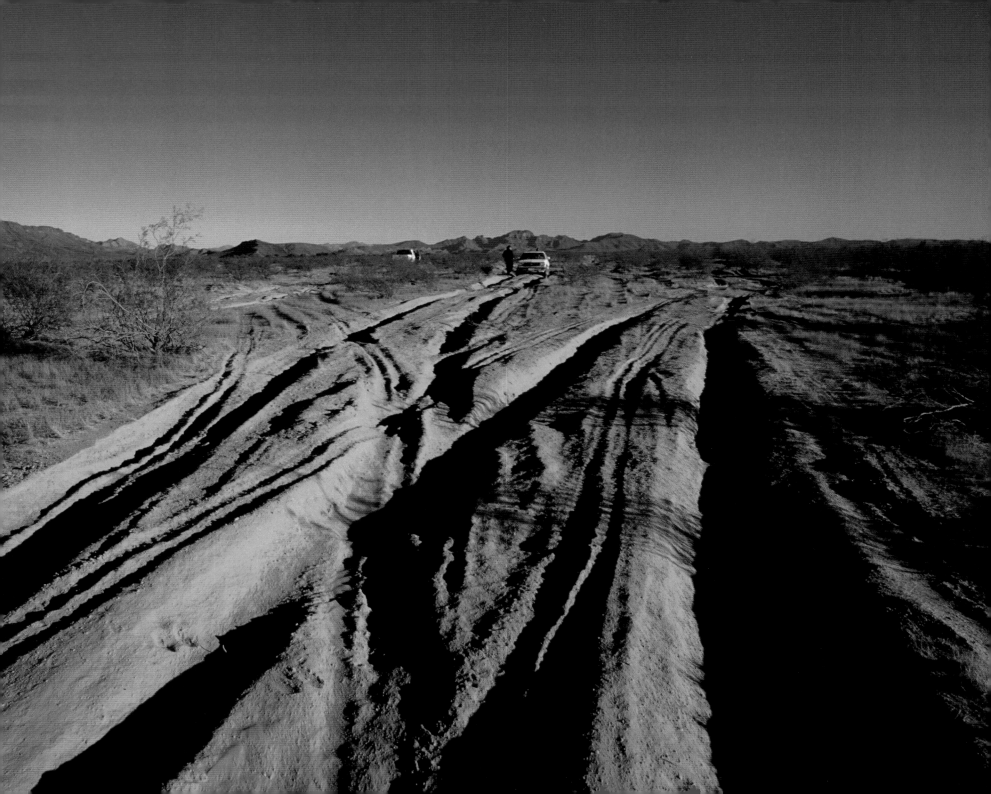

to west—along with the historic trails that crisscrossed the line north-and-south—and revisit the natural wonders I'd explored before, photograph the secret beauty hidden behind the headlines, and survey what remains (and what's fallen prey) in the borderlands of Texas, New Mexico, Arizona, and California; and of Nuevo León, Coahuila, Chihuahua, Sonora, and Baja California Norte, México.

In this beautiful, rugged, awe-inspiring landscape that once lured conquistadors, missionaries, scalp hunters, bandits, Texas Rangers, pioneers, and colonists, I canoed the Rio Grande/Río Bravo del Norte through the legendary Big Bend frontier, walked the infamous *Camino del Diablo*, "Highway of the Devil," explored the realm of the borderlands jaguar on foot, and met resilient people who still live, work, and cling to traditions on both sides of the line.

The UNESCO World Biosphere reserves, national parks and monuments, wilderness areas, and national wildlife refuges that I visited throughout the borderlands, I discovered, were the last sanctuaries for threatened and endangered species such as the Sonoran pronghorn antelope, desert bighorn sheep, Mexican jaguar, and Vaquita porpoise, as well as the indigenous people who once traveled freely across a land divided. But many of the fragile ecosystems of these vibrant bioregions, shared by the United States and Mexico, have fallen prey to the heavy "footprint" of deadly border traffic and a steel border wall that threatens to be the death knell for the natural landscape, wildlife, multilingual people, and cultures that wove the colorful mosaic of the borderlands' common ground. I wanted to portray the astonishing beauty of this

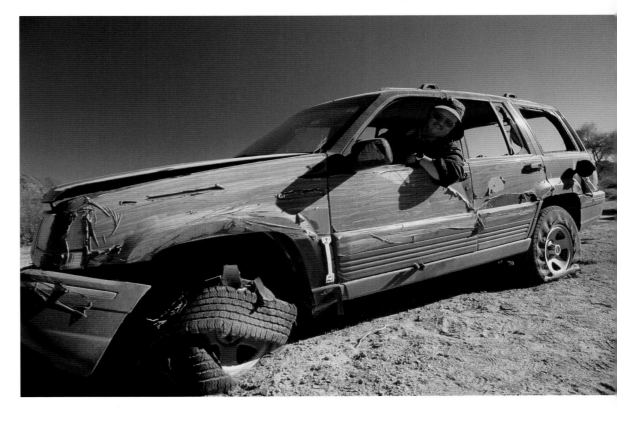

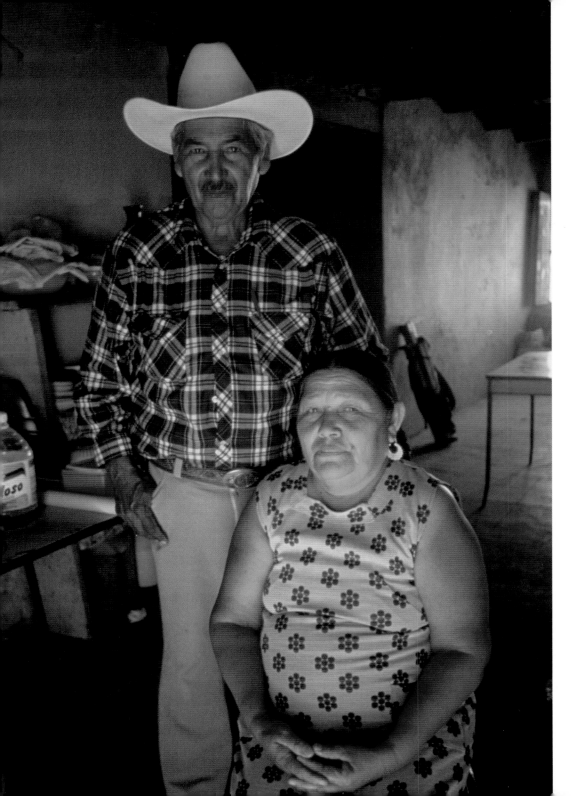

mythic landscape, but I was convinced I should include discerning images, passages, and maps that underscored the forces that now threaten to destroy it—or anyone who now ventures into it down the wrong road or trail.

This book is about those mesmerizing, sometimes perilous journeys through the United States's and Mexico's vanishing borderlands. They proved to be a revelation for me. I hope they are enlightening and engaging for you.

LEFT: *One People, A Land Divided; tribal leader Eugenio Velasco Ortega and wife Herlinda León Pacheco, Quito Wa:k, Sonora. Descendants of desert dwelling Hohokam, the Tohono O'odham once traveled freely across ancestral lands that were divided by the United States/Mexico border.*

OPPOSITE: *Tohono O'odham tribal members from Arizona and Sonora are now required to use border crossing cards to visit family members or get medical help on the other side. This is impossible for many like Chico Shunie, who was born at home without a birth certificate.*

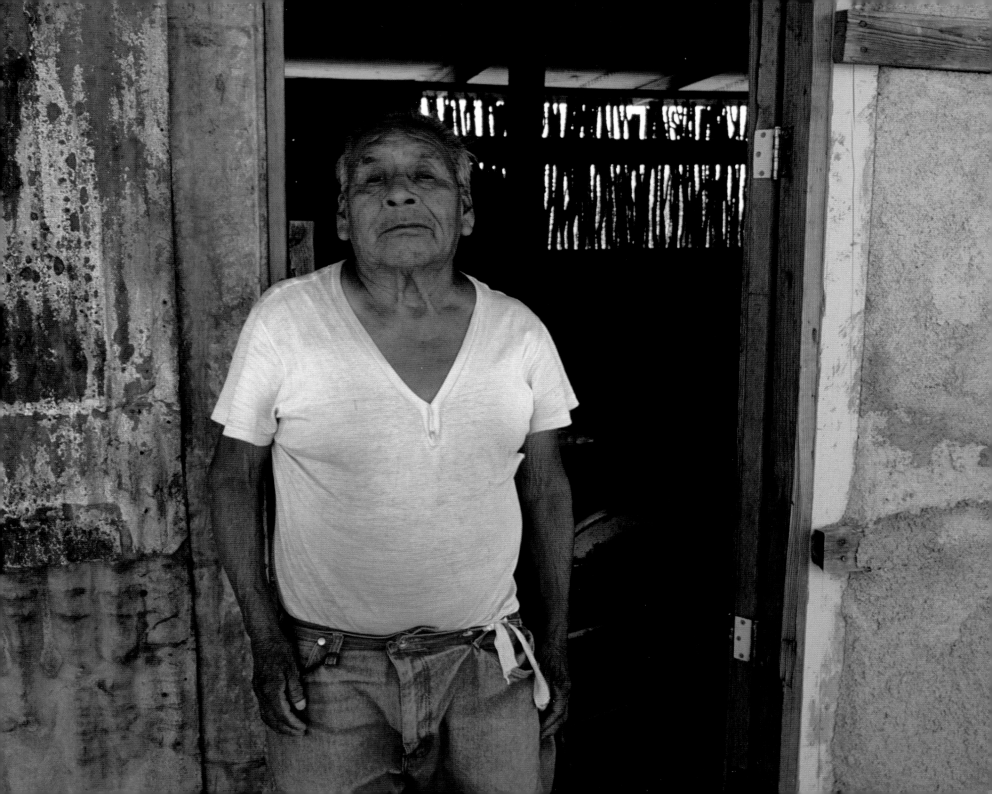

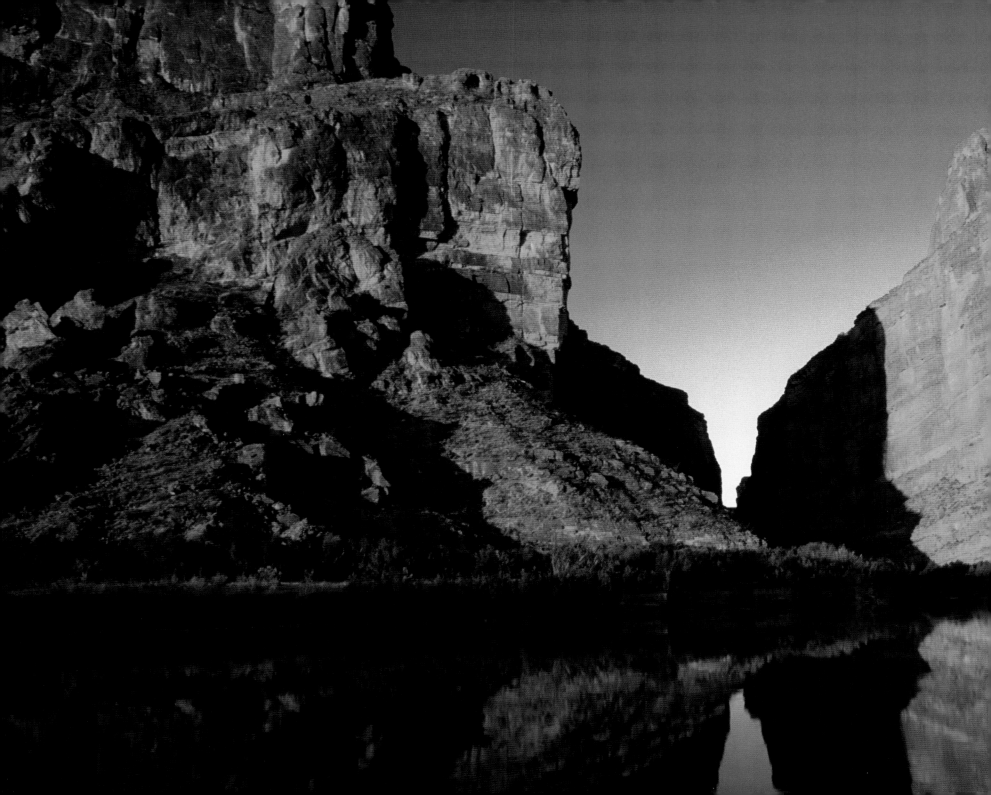

la frontera
Wild at Heart

Late in the afternoon of their second day's voyage
Hill and his men entered . . . the first of the series of canyons
of the Rio Grande . . . they were to be entombed for the succeeding weeks.
It was called Murderer's Canyon.

– PAUL HORGAN
GREAT RIVER, 1954

SUNRISE DAWNS OVER TWO NATIONS AS OUR CANOES GLIDE DOWN A RIVER OF no return. We are paddling into wild country toward sinuous gray cliffs that pinch out the blue sky. Ahead lay two-thousand-foot-deep chasms that were cleaved by the ancient river. They bear Spanish names—*Colorado, Santa Elena, Mariscal,* and *Boquillas*—and they coined the region's violent geology, blood-stained landscape, and saints, sinners, and lawmen who once reigned over it. Born in the snow fields of Colorado's San Juan Mountains, the timeless watercourse we now paddle one stroke after another still sought its path to the sea 1,896 miles downstream from its source in the warm waters of the Gulf of Mexico. The serpentine, deep-water channel we trace day after day delineates the United States–Mexico border between Texas and Chihuahua, Coahuila, Nuevo León, and Tamulipas. But it was impossible to know when we drifted over the elusive silver thread that slithered beneath dark igneous rock bristling with bayonet yucca, prickly pear cactus, and ocotillo. On one side of this figment, the river is called the Rio Grande; on the other, it is Río Bravo del Norte. By any name, it became the River of No Return for many.

The glimmering mirage of cool water purling through desolate wastes that reached 110 degrees during summer was the lifeblood for indigenous Jumanos and Mescalero

25

Apaches who thrived along the river's verdant corridor before they were massacred by Spaniards, Mexicans, and Texans. All manner of good men and bad staked their claim in the harsh ground that gave up the bones and spirits of slain Indians, who fell in open graves that stretched a hundred miles across the Chihuahuan Desert in both directions from the river. North of the Rio Grande, Americans called it the Last Texas Frontier. South of the Río Bravo, Mexicans called it *La Frontera,* "The Frontier."

Among the cattlemen and cattle rustlers, smugglers and settlers, scalp hunters and Indians who crossed the river and changed sides and loyalties as often as opportunity presented itself—or survival demanded—few men were as feared in Big Bend as Chico Cano. Bandit, *pistolero,* and family man, Cano was a hero in *La Frontera* because he lived, stole, and killed by his credo: *Su familia, su tierra, su hogar* ("Your family, your land, your home"). They came first, until Cano was captured by Texas Rangers in 1918 for the deadly raid on cowman Ed Nevill's Ranch that killed his wife, son, and Mexican ranch hand. Cano escaped and fled back to Mexico but made repeated raids across the border, killing Texas Ranger Eugene Hulen and two U.S. Customs Inspectors, Jack Howard and Joe Sitter, before dying peacefully in Pilares, Chihuahua, in 1943.

The Rio Grande/Río Bravo has lured many others since the dawn of history, including conquistadors, Comanches, Villistas, and U.S. Geological surveyors, who, in 1899 were "Intrigued by rumors of ghosts in the Chisos Mountains, bandits lurking along the river, and 7,000-foot gorges." Our group is among them—though I know of no mile-and-a-half-deep canyons. We are paddling the historic byway of Texas Ranger Charles L. Nevill, who proudly wore a five-point silver star cut from a Mexican five-peso coin. The lanky ranger and his seven-man crew whom he called "the greenest set of boatmen that ever started down any river," made a perilous journey down the unexplored river during the winter of 1881–1882.

Lured by such legends and landscapes, our flotilla of canoeists is as green as any to embark on a ten-day, eighty-five-mile journey down a bold river that carved the dog-leg-turn of "big bend" through its landmark canyons. In this beautiful and forlorn landscape that Americans enjoy on one side of the river, Mexicans still struggle hand to mouth in hamlets of crumbling adobe and mud that vie for life on the other side. For them, it is *El Columpio del Diablo,* "The Devil's Swing." In spite of the vibrant mix of language, culture, and geography that formed the borderlands' common ground, this is a world divided—

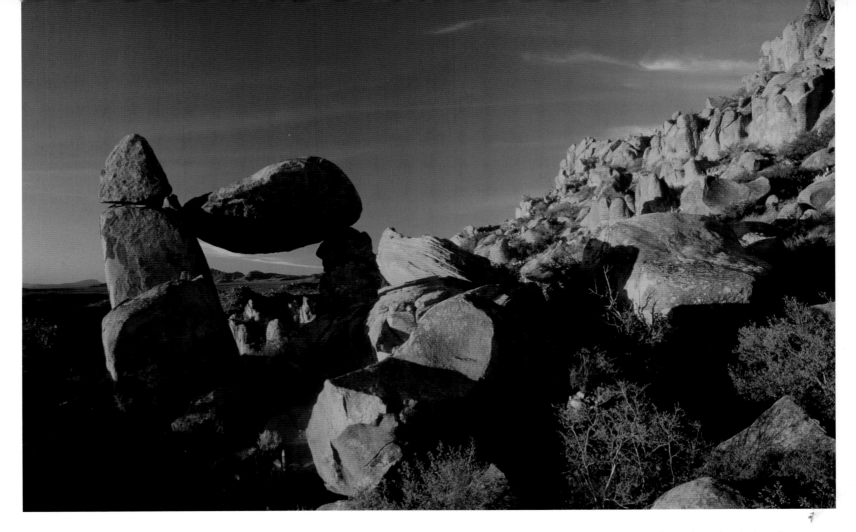

where the Third World often collides with the New World, erupting in passion, violence, and blood feuds between the haves and the have-nots. It is bad country that has never escaped its past, where gunfire still settles scores and shapes people's lives the way the landscape once did.

Much of Big Bend's history was written in this blood. Locals on both sides of the river once feared September's Comanche Moon. Witnessing their ancestral lands plundered by American pioneers who believed Manifest Destiny was their God-given right, horseback Comanches crossed the Rio Grande on raids that stretched eight hundred miles south to Durango and Zacatecas. Their bloody trail of thundering hooves into Old Mexico was so

Balanced Rock, Big Bend National Park, is a popular landmark for visitors. Big Bend's Chihuahuan Desert ecosystem was recognized for its uniqueness by UNESCO as a Man and the Biosphere Reserve.

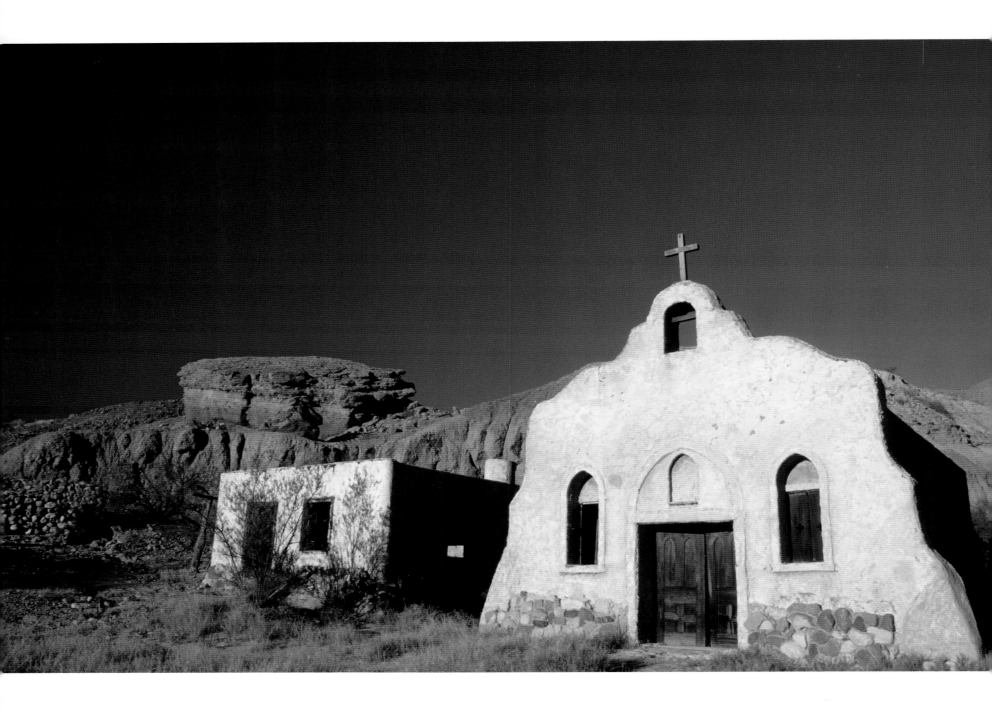

heavily beaten during the 1800s, it became the official border between Chihuahua and Coahuila. Francisco "Pancho" Villa cut his own swath of infamy across Chihuahua during the Mexican Revolution. Sensing that hundreds of American mercenaries would join him, Villa's men tacked up recruitment posters:

ATENCIÓN GRINGO:
FOR GOLD & GLORY, COME SOUTH OF THE BORDER AND RIDE WITH
PANCHO VILLA, EL LIBERATOR [SIC] OF MEXICO!
WEEKLY PAYMENTS IN GOLD TO DYNAMITERS, MACHINE GUNNERS, RAILROADERS.
ENLISTMENTS TAKEN IN JUÁREZ, MEXICO.
VIVA VILLA! VIVA REVOLUCIÓN!

American journalist Ambrose Bierce heeded the revolutionary's siren call in 1913 and was officially attached to Villa's army as a journalist for William Randolph Hearst. During the Battle of Tierra Blanca in November, the seventy-one-year-old "observer" was given a *Sombrero Villista* for shooting and killing a Federale. But the "old gringo" didn't wear his wide-brimmed sombrero for long. Little more than a month later, Bierce disappeared in the Battle of Ojinaga on January 9, 1914. No one knows where he fell, but in an earlier letter, Bierce wrote: "If you hear of my being stood up against a Mexican stone wall and shot to rags, please know that I think it a pretty good way to depart from this life. It beats old age, disease, or falling down the cellar stairs."

Several days earlier we slipped our canoes into the river below Redford, Texas—country that still bears the legacy of Villistas and Comanches. We worked out the kinks by paddling through forgiving, canoe-tipping rapids, and craned our necks in awe as the river meandered beneath menacing dark cliffs of rhyolite and basalt that formed the 1,100-foot-deep gorge of Colorado Canyon. No mention was made of the river runners who spilled blood rafting this same river. There was no reason to scare anyone. This was an Executive Outward Bound expedition, and most of the canoeists were CEOs and businessmen from Manhattan who embraced the river's challenges that would transform them by journey's end.

Thoughts of the Colorado Canyon shootings quietly unnerved me as we paddled beneath the imposing cliffs. Pointing the bow of my canoe south, I could see that there was still no place to run and no place to hide, a hundred years after Nevill, four other Texas Rangers and three surveyors paddled through Murderer's Canyon. On November 19, 1988,

OPPOSITE: *Dead Man's Mission, Big Bend Ranch State Park, Texas. Evoking the Mexican border town of Ojinaga for the movie* Streets of Laredo, *the Contrabando Creek film set was built in historic smuggling country once controlled by* contrabandista *Pablo Acosta.*

four young Mexican gunmen perched on the cliffs looming above us opened fire on three Americans. The rafters fled for cover in the river cane that now surrounded our canoes, but the deadly hail of .22-, .30- and .44- caliber rifle fire left a trail of agony and despair. Nearly crippled from gunshot wounds, river guide Jim Burr clawed through cactus, crawled over rocks, and staggered bleeding to reach help to save his client Jamie Heffley. She'd been seriously wounded. Burr saved her life. But it was too late for her husband, Mike. The river that now captivated us had run red with his blood. Ten days later, Texas Ranger Joaquin Jackson crossed the Rio Grande and brought the Vietnam combat veteran's four killers to justice.

We had entered historic smuggling country, where candelilla wax and moonshine sotol once moved north across the river, and stolen horses, mules, cattle, and guns moved in both directions. During the 1980s, the Rio Grande/Río Bravo upstream and down from our canoe expedition was the domain of Pablo Acosta. He made no apologies for his deadly trade of smuggling drugs through the Columpio del Diablo. But the year before Heffley was murdered, Acosta took his last breath, where he had been born, during a fiery gun battle with Federal Judicial Police, who staged a surprising helicopter assault on his Santa Elena adobe from the American side of the river. April 24, 1987 was a sad day for locals who sang *corridos* and bid farewell to *El Padrino,* a dirt-poor villager turned infamous *contrabandista* who had lavished their poverty-stricken lives and dreams with drug money.

In the aftermath of Acosta's reign, a Marine sniper camouflaged in a ghillie suit shot and killed eighteen-year-old American goatherd Esequiel Hernández Jr. in his back-yard during drug war maneuvers outside Redford, Texas, on May 20, 1997. The Columpio del Diablo's violent legacy was not washed away by the Rio Grande—or by the tears that fell on the grave of Esequiel Hernández. Six years later Mexican paramilitary police or soldiers crossed the river fifty miles upstream from Redford and kidnapped an American family of five in Candelaria in the heart of Chico Cano's old haunt, an incident ignored by the American press.

As we paddle into Santa Elena Canyon the next day, it is difficult to fathom the natural forces that carved a nineteen-mile-long gorge through limestone walls that tower fifteen hundred feet above us. The white-stained ledges and cliffs are perches for peregrine falcons—which prey on cliff swallows, white-wing doves, and sandpipers. The Big Bend's amazing diversity of four hundred other species of birds include golden eagles that dine on

OPPOSITE: *Hoodoos, Big Bend Ranch State Park. The natural wonders of the Chihuahuan Desert borderlands include mystifying hoodoos like* El Padre al Áltar, *"The Father at the Altar."*

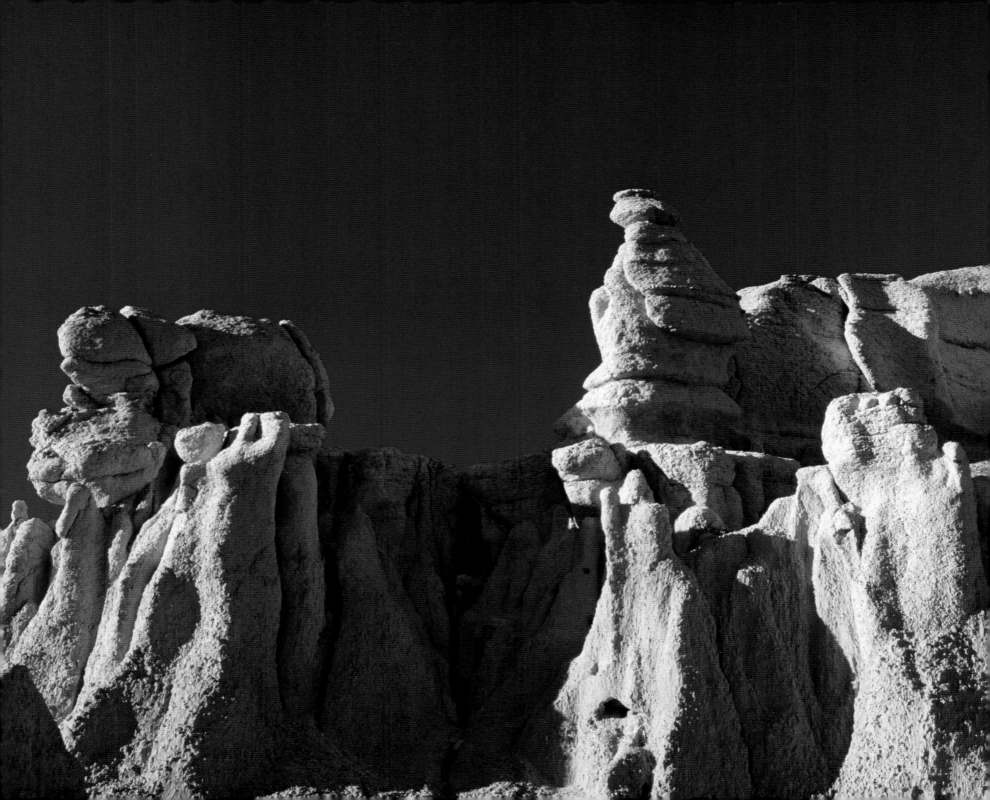

their own fare of rabbits and rodents. The river itself is home to mud turtles, sunfish, garfish, leopard frogs, and beaver. And the riverbanks, I saw, came alive with roadrunners that darted after myriad species of lizards, and returned with their limp prey dangling from their beaks. Black bear, mule deer, and mountain lion also drink from the river that links the vibrant transborder ecosystem. The United States and Mexico have long recognized the Rio Grande/Río Bravo's rich biodiversity. Texas protects one side of the river with national park and Wild and Scenic River status, while Chihuahua protects the other side with its own sovereign designation, *Cañón de Santa Elena Área de Protección.*

But everything and everyone ignores the border in these parts. After two hours of portaging our canoes over house-sized boulders in the canyon's oven heat, we pull over on the south side of the river to scout the Rock Slide. It was created by an exfoliating wall of rock that peeled off the Mexican rim of the canyon. We scout the labyrinth of boulders that must be negotiated before we emerge from the Rio Grande's biggest obstacle. Most of us manage to slalom through the slide upright; others with less skill swim after their canoes. We collect the swimmers and detritus in the eddies below and camp on a sandbar on the American side of the river.

Staring into the flames of our campfire, I am struck by events that shaped this extraordinary and dangerous paradise. No one place on either side of the river in Big Bend has seen more bloodshed than Santa Elena Canyon. Under the command of Captain John Glanton, a ruthless band of American scalp hunters crisscrossed the river on horseback in 1849 and massacred 250 Mescalero Apaches at their winter camp—somewhere near our camp—for the $200 bounty the governor of Chihuahua, Mexico, offered for each scalp. The spirit of Big Bend beats through the wild heart of its river canyons like Santa Elena and the others we'll be navigating in the coming days. The river is its pulse. So I put my ear to the ground and try closing my eyes, but the soothing river music could not drown out the screams and cries I hear echoing off the canyon walls long into the night as I watch shooting stars streak back and forth across the canyon rims of two countries.

When we emerge from Santa Elena Canyon the next day, a vaquero is standing with his horse on the Mexican side of the river. He waves us over. He's looking for a stray calf he thinks wandered over to the other side. Our guides oblige him and ferry him across the political boundary that divides two nations. The remote borderlands, I see, are still shared by locals who wrest a living from hard country on both sides of the Rio Grande/Río Bravo.

OPPOSITE: *Terlingua Creek, Big Bend National Park. "Terlingua" is a corruption of the Spanish* tres lenguas, *meaning the "three languages" (Spanish, Indian, and English) spoken in the Big Bend frontier. Terlingua Creek offered a glimmer of hope for Mexican settlers.*

As one day slides into the next, the pace of our river journey picks up. What had been strange and unexpected has become familiar for the Outward Bounders. They've mastered rudimentary canoeing skills, and the stiff chatter of strangers has transformed into camaraderie amongst friends. The scenery—as spectacular as the six-mile long, 2,000-foot deep Marsical Canyon is—has the homey feel of a Grand Canyon tributary to me. The river has worked its magic.

So do the locals we visit in Boquillas del Carmen, México. Descendants of refugees from the distant frontier pueblos of Coahuila, they've struggled to survive in the Big Bend frontier since laboring in the Corte Madera mine in 1896, then later as candellilla wax makers in the 1920s, and finally as congenial hosts for American tourists they've ferried back and forth across the river from the time Big Bend National Park was established in 1943. Their *pueblito* is the one river hamlet that had managed to escape the scourge of drugs and violence that gripped Polvo, Santa Elena, and San Vicente, and I feel honored to meet proud people who have endured in the face of such economic and environmental adversity.

We bid our farewells to these friendly folks, walk down to the river, and slide our canoes into the mouth of Boquillas Canyon. The three-day journey through the seventeen-mile long, 2,300-foot gorge and what lay beyond turns out to be the highlight of the trip for me. Here two worlds came together. On one side of the river, UNESCO had designated Big Bend National Park an International Man and the Biosphere Reserve. On the opposite side, UNESCO had also designated the *Maderas del Carmen Área de Protección* a Man and the Biosphere Reserve. Nowhere else along the 1,956-mile United States–Mexico border do both countries share such a distinction—and nowhere else do both countries still have the opportunity to create the international peace park and protect the transnational megacorridor first proposed by Texas senators in 1933. By the time we unload our canoes at La Linda, Texas at journey's end, I am eager to return.

I've visited Big Bend many times since that expedition. I have an affinity for the landscape and a fondness for the people. When I made my last visit in the fall of 2007, Big Bend had undergone a sea change. Reduced to a trickle and poisoned by urban, industrial and agricultural runoff, the Rio Grande/Río Bravo del Norte was not the same spirited waterway I first paddled. A hundred-year drought reduced runoff from the Sierra Madre's Río Conchos, which historically recharged the feeble river below El Paso. Virulent stands

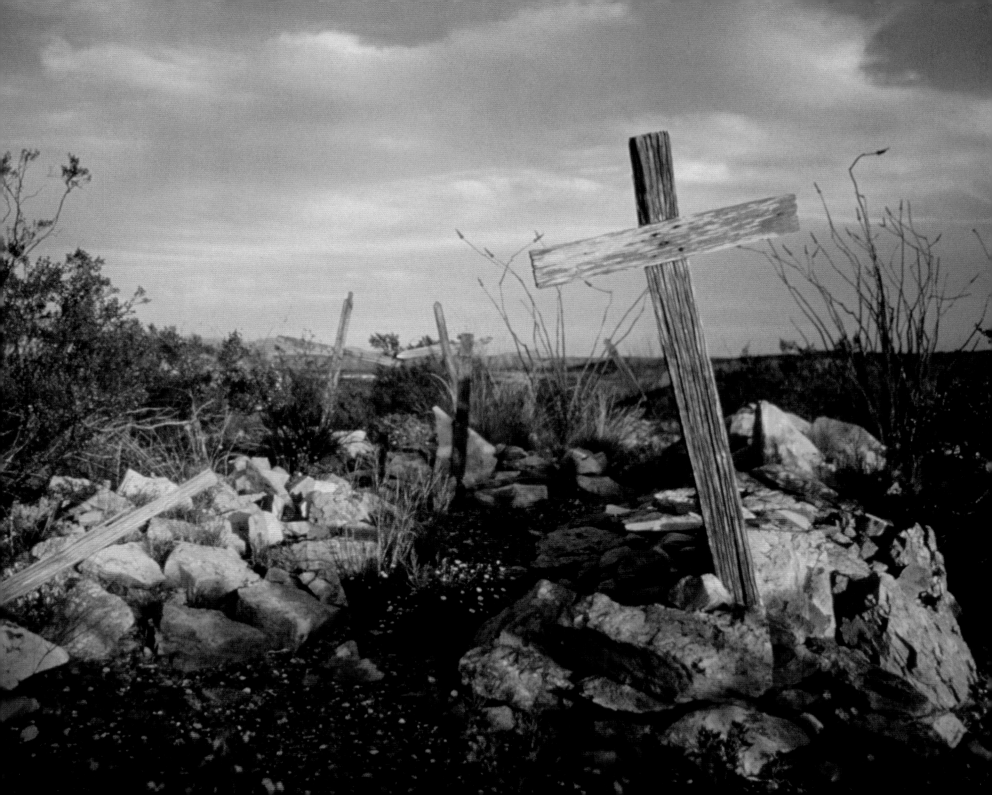

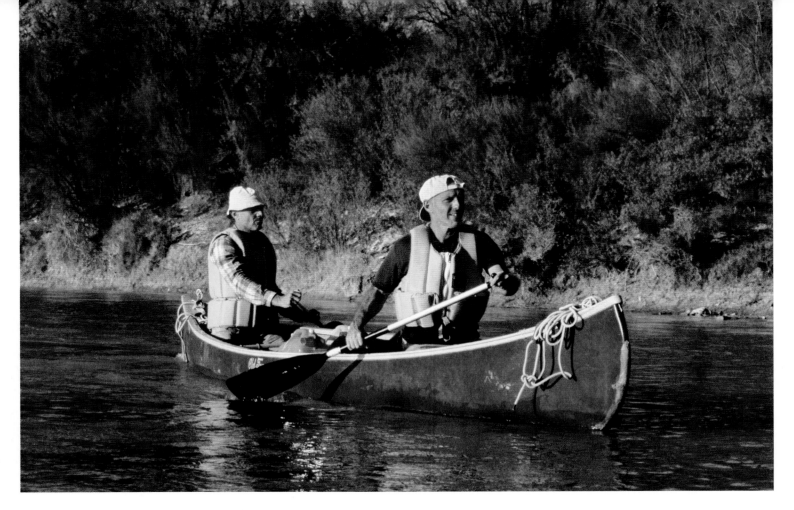

Canoeists paddle the historic byway pioneered by Texas Ranger Charles L. Nevill and his crew, in the winter of 1881–1882.

Vanishing Wetlands, UNESCO World MAB Reserves, Big Bend National Park, Texas and (left) Maderas del Carmen Área de Protección de Flora y Fauna, *Coahuila, México.*

of exotic Middle East tamarisk, introduced to Western rivers in the 1900s, choked once healthy wetlands that were the last refuge for a diverse array of fish, wildlife, and birds. The natural world of the borderlands was vanishing.

So were its people. In the wake of 9/11, the border crossing was shut down. Tourists who'd regularly visited Boquillas faced stiff fines and jail sentences if they crossed the river. Boquillas residents who depended on the park's store for food, gas, lantern kerosene, and emergency phone calls faced apprehension if they crossed the river. One store owner told me Big Bend visitation dropped 40 percent because the lure for many tourists had been Boquillas. Boquillas, in turn, was nearly reduced to a ghost town after many families moved away in the face of more hardships imposed by new border

seen smuggling contraband across the river to the west, but for DTOs (Drug Trafficking Organizations), it was far more profitable to end-run around Big Bend's formidable geographical border through official ports of entry or more accommodating topography.

One man—as I saw in a video when I returned home—offered hope amidst the fears. His name is Victor Váldez, and I photographed him reading his Bible in his adobe the year I visited Boquillas to climb the Sierra del Carmen. He was standing waist deep in the middle of the river beneath the looming yellow cliffs of the Sierra del Carmen, singing to American tourists verses from Quirino Mendoza y Cortés's 1882 *campirana* love song, *"Cielito Lindo"*:

"From the mountain ranges, heavenly pretty,
are coming down.
A pair of black eyes, heavenly pretty,
that are being smuggled. Ay, ay, ay, ay
sing and don't cry . . .
From your house to mine, heavenly pretty,
there's only one step.
Now that we're alone, heavenly pretty,
give me a big hug.
From our house to yours, heavenly pretty,
it's only one step."
But we can no longer cross the river, heavenly
pretty, to give our neighbors a big *abrazo*.
Ay, ay, ay, ay canta y no llores.

RIGHT: *Outward Bound guide Cecilia McClung waits downstream while* (OPPOSITE) *Rodney Woods tests his paddling skills during a Big Bend canoeing adventure.*

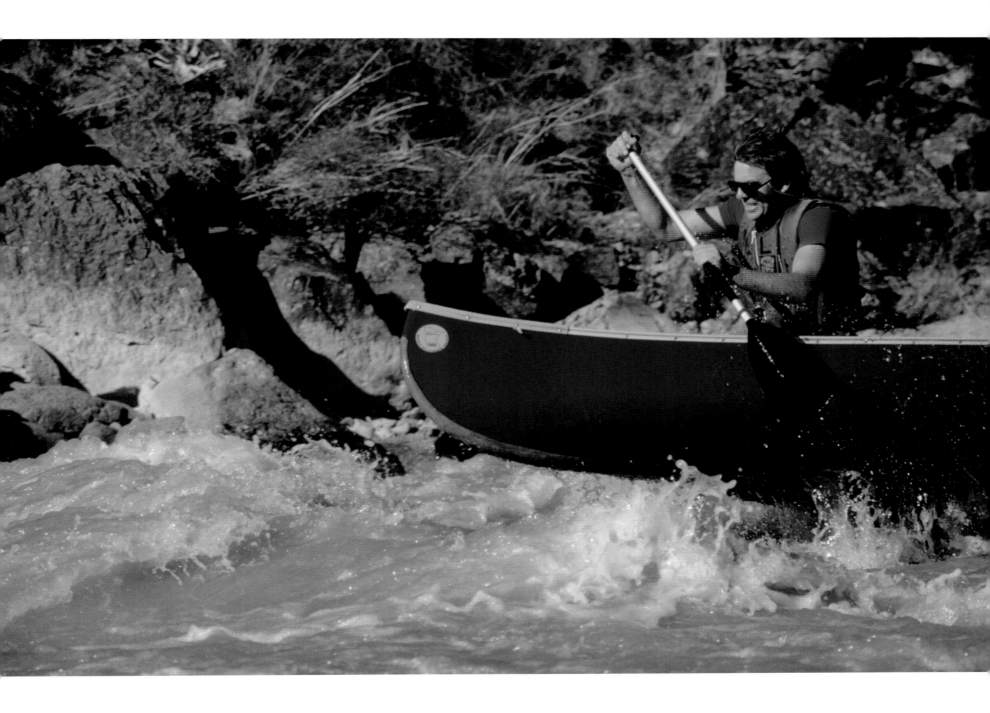

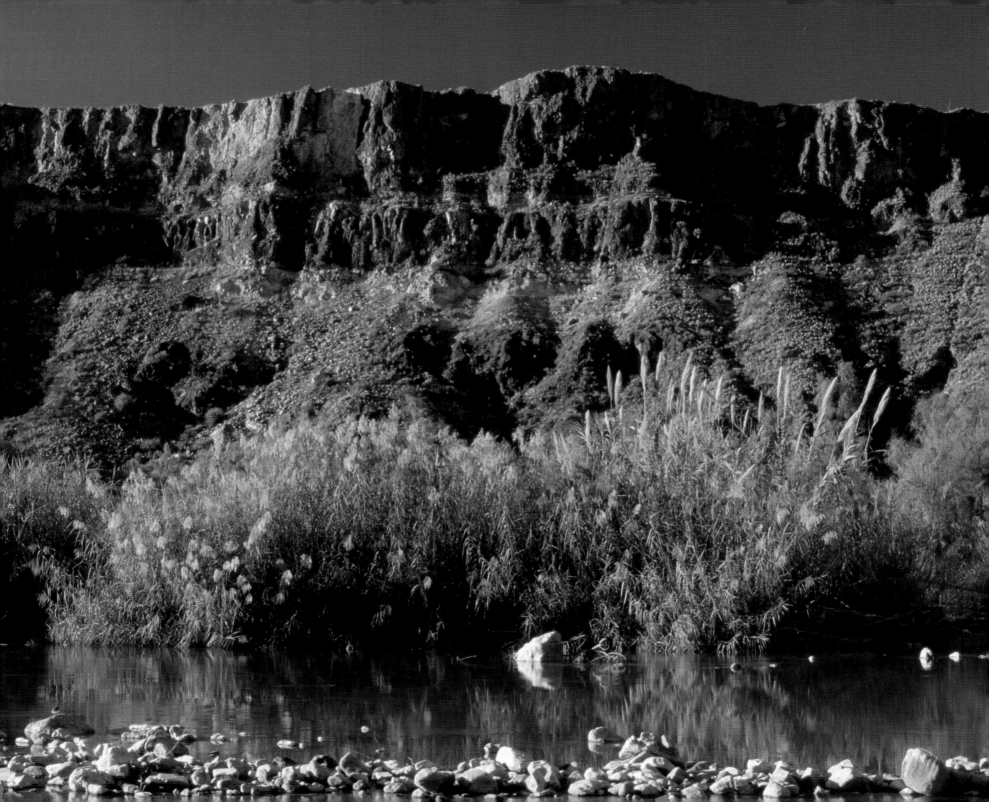

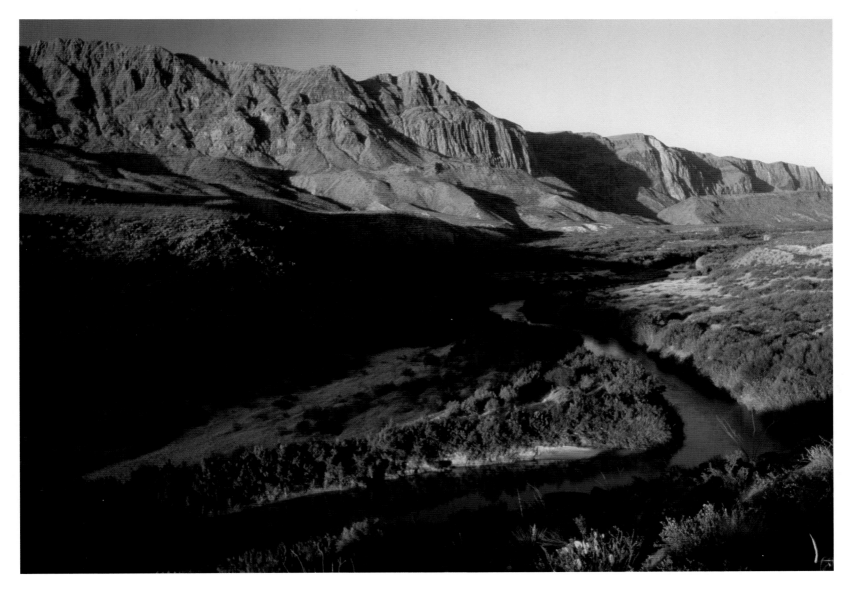

The River of No Return, Big Bend Ranch State Park. In 1988, four Mexican gunmen perched on cliffs above Colorado Canyon shot three Americans rafters (OPPOSITE). *Not far from the Colorado Canyon shootings, a Marine sniper killed 18-year-old American Esequiel Hernández Jr. during drug-war maneuvers along the Rio Grande in 1997.*

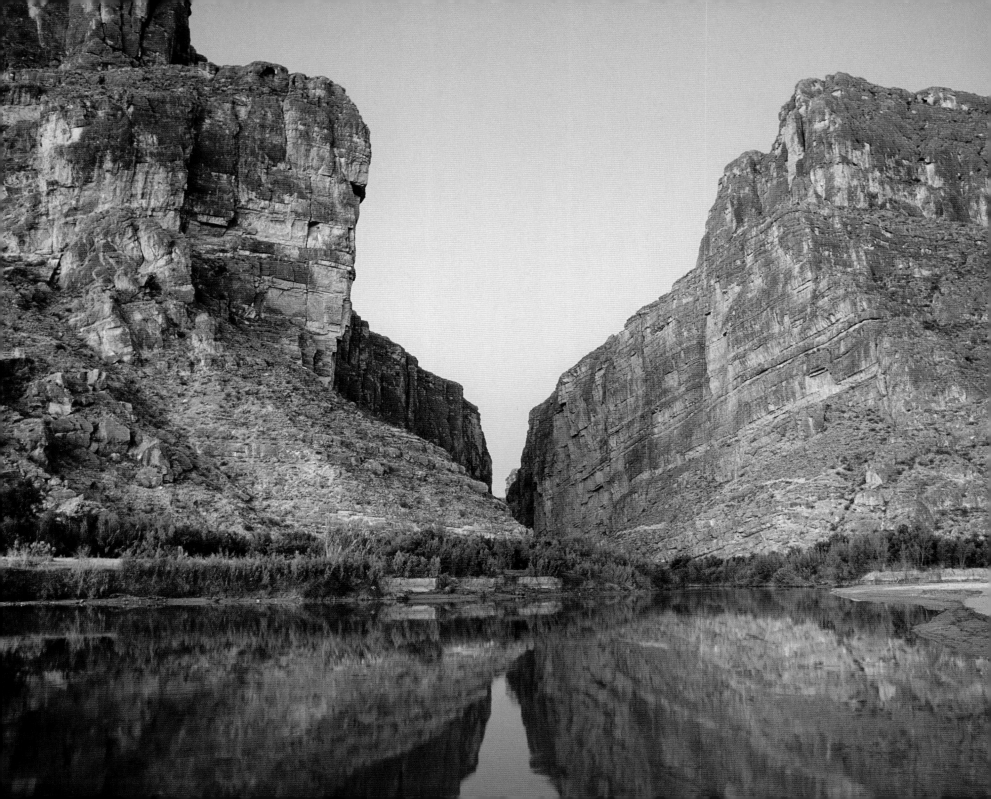

By the light of a campfire, Rodney Woods contemplates his canoe journey down the Rio Grande. (OPPOSITE) *An icon for Big Bend country, Santa Elena Canyon is the site where 250 Mescalero Apaches were massacred by scalp hunters during the winter of 1849–1850.*

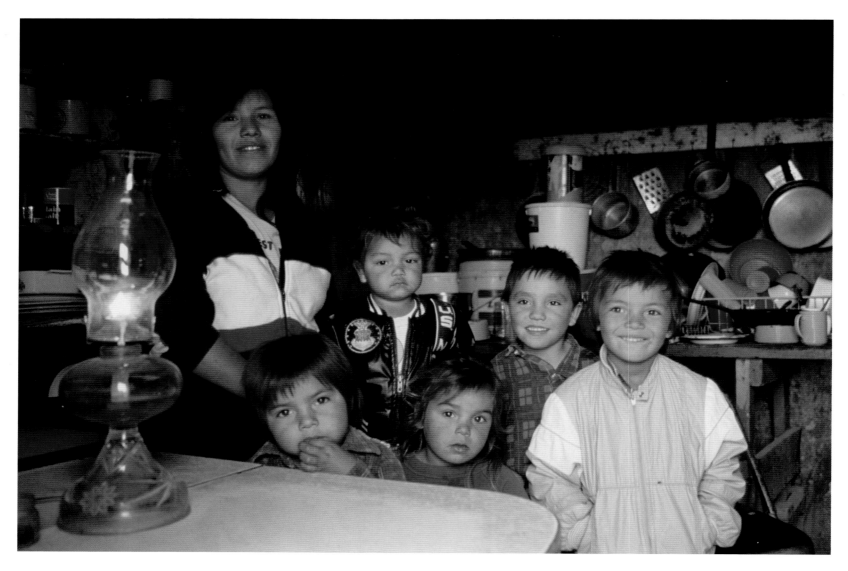

Lantern light, Sylvia Ureste family, Coahuila. Cut off from electricity enjoyed by Americans across the Río Bravo in Big Bend National Park, Boquillas del Carmen families rely on lanterns to survive in the frontier of Coahuila. (OPPOSITE) *Sierra del Carmen, UNESCO World MAB Reserve, Coahuila. Strung between cliffs of the Sierra del Carmen and the floor of Big Bend, the Corte Madera Mine's aerial tram carried lead and zinc ore six miles across the Rio Grande/Río Bravo during the 1900s.*

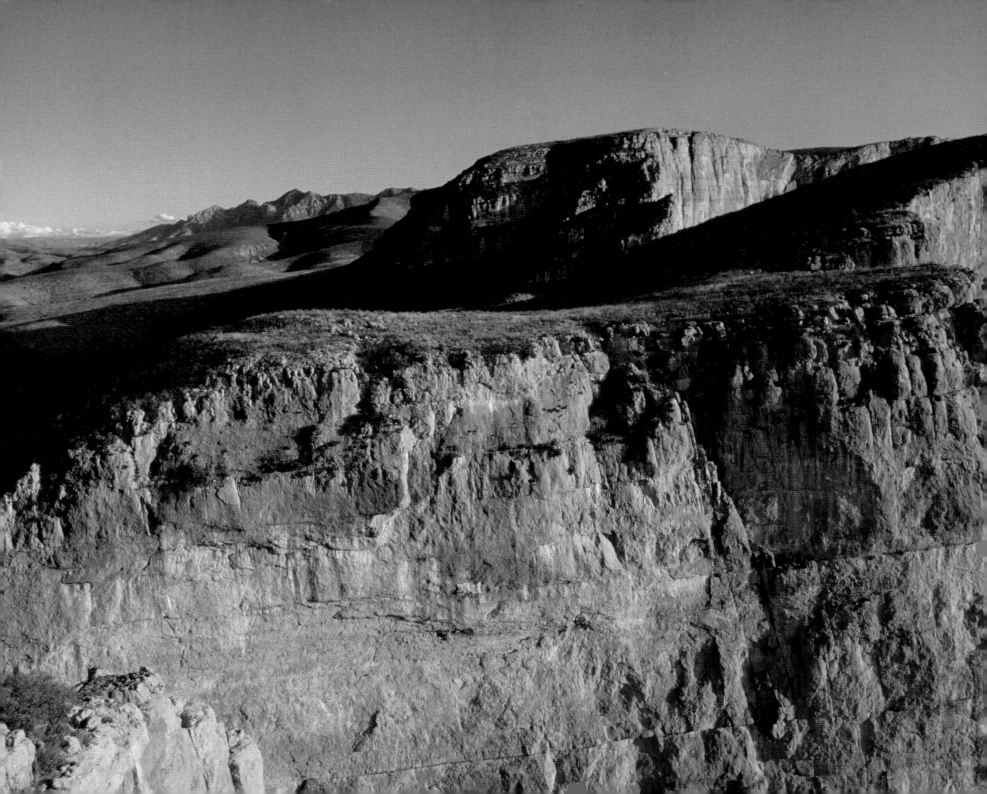

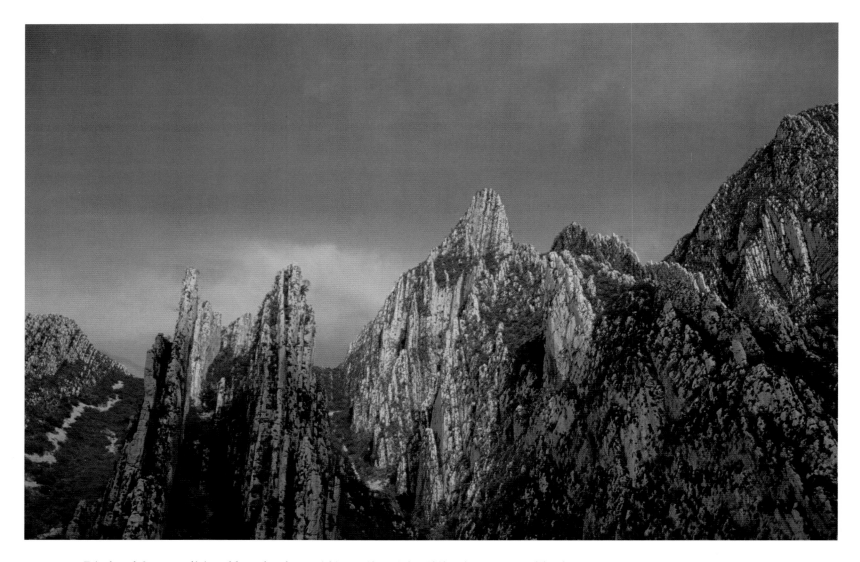

(OPPOSITE) *Displaced from traditional homelands, vanishing tribes of the Chihuahuan Desert like the Pamé proffer golden eagles* (Aguila chrysaetos) *to smugglers in a desperate bid to stave off starvation. The Convention on International Trade in Endangered Species was signed by 160 countries, but illegal global trade generates $4.2 billion annually, primarily from American and European buyers.*
(ABOVE) *The sub-tropical peaks of* Parque Nacional de Cumbres de Monterrey *in Nuevo León, a UNESCO World MAB Reserve, link Mexico's Sierra Madre Oriental with the Rocky Mountains in the United States.*

48

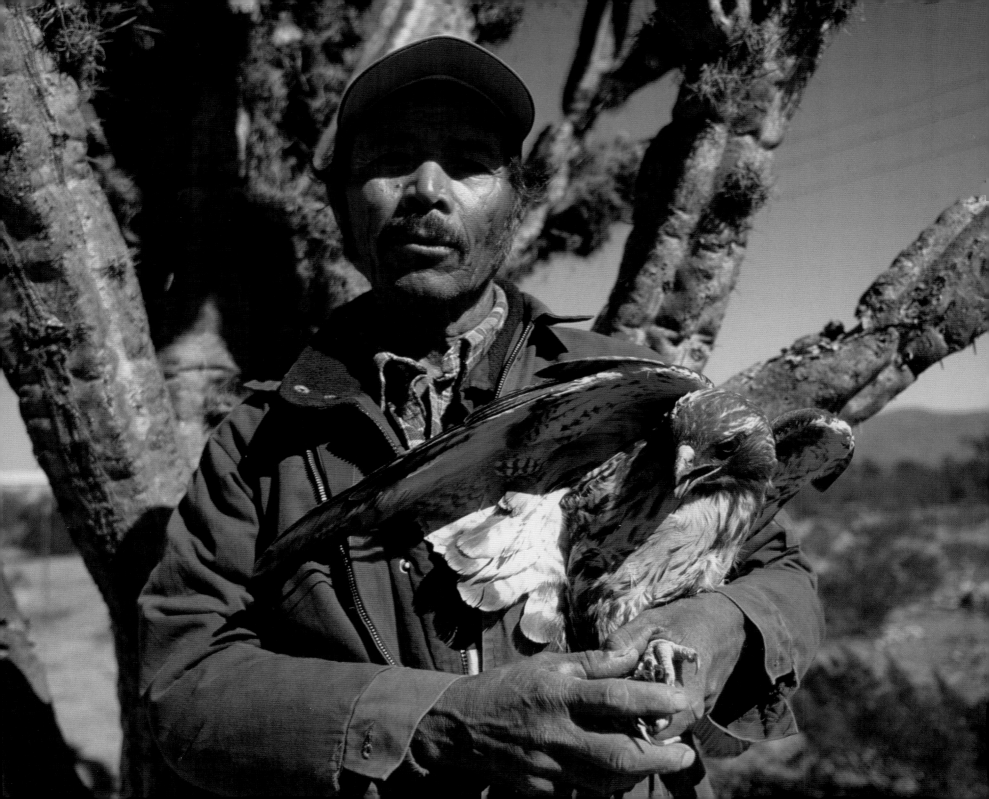

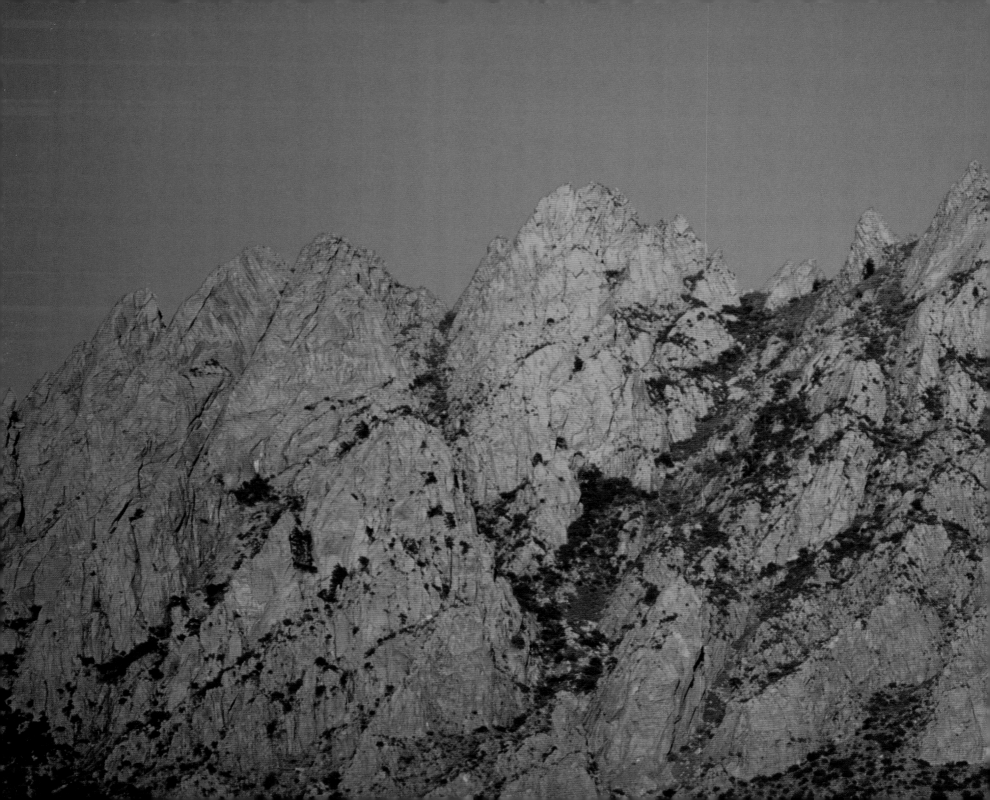

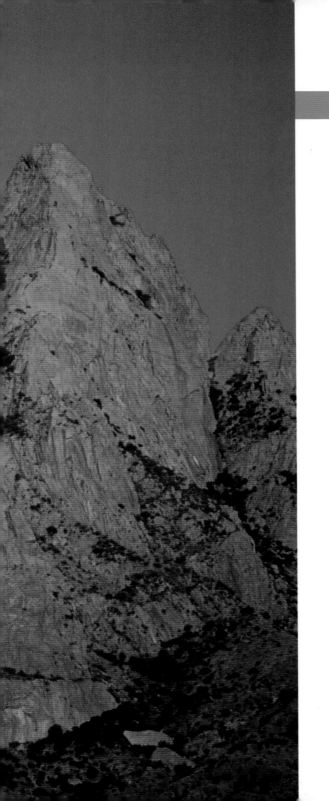

entrada

Coming into the Country

SOUTHEAST ARIZONA, BOOTHEEL OF NEW MEXICO AND CHIHUAHUA, MÉXICO

Around the camp fires of Mexico there is no animal talked about,
more romanticized and glamorized, than *el tigre*.
The chesty roar of a jaguar in the night causes men to
edge toward the blaze and draw serapes tighter.

— A. STARKER LEOPOLD
WILDLIFE OF MEXICO, 1959

I AM WALKING THROUGH A GOLDEN SEA OF SACATON GRASSLAND SURROUNDED by pyramids of blue mountains that loom up from the borderlands and float in the dark skies. On one side of the barbed wire, the purple veil of the Sierra Madre arcs 750 miles south across the Republic of Mexico. On the other, the misty crags and ridges of the Pedregosa, Chiricahua, and Dos Cabeza Mountains beckon my footsteps north. Brilliant flashes of white lightning erupt beneath a thundering palette of charcoal-gray clouds. Heavy pellets of rain sting my neck and arms until the storm cell passes. The soft drizzle of cool rain is a welcome relief in the August heat. I trace the rim of Silver Creek Wash through spiny clusters of hedgehog cactus that bloom with scarlet flowers.

Summer monsoons have soaked the neighboring Bootheel Country for days, and the rumble and roar of flashfloods has swept the arroyos and streambeds clean. I ski down the embankment and walk through hard-packed sand and gravel beneath drooping green canopies of mesquite and palo verde laden with crystal droplets of rain. The creek winds upward, turning this way and that way until it straightens out and reveals the mysterious mountains beyond. In an instant, a big cat crosses the path in front of me at a trot. My adrenalin races. The long tail hangs low, and the body is bigger than the white German

PREVIOUS PAGE: *Organ Mountains, UNESCO World MAB Reserve, New Mexico. The Tertiary-aged granite spires of the Organ Mountains were an inspiring setting for Italian healer Giovanni Maria Agostini-Justiniani, who lived in* La Cueva, *"the cave," beneath the peaks until he was murdered on April 17, 1869.*

OPPOSITE: *Bootheel Country, New Mexico. Traversed by conquistador Álvar Núñez Cabeza de Vaca in the 1530s, the Bootheel country became the domain of lawless men.*

shepherd I loved as a boy. And then it vanishes. My heart pounds, and my heavy pack slides back and forth like a loose saddle as I run to get another fleeting glimpse of the phantom. But it is gone.

I bend over, gasping for air, then stoop down and examine the paw prints in the wet sand. I place my right hand over one of the deep impressions—but it is bigger than my palm. There are no claw marks, so it can't be a ranch dog gone wild or a Mexican gray wolf, which once had free run of the borderlands before they were shot, poisoned, and exterminated by cattle ranchers and government hunters. It was a mountain lion—it had to be. It couldn't be a jaguar. Could it? I wasn't sure. Jaguars had been killed and trapped in the Chiricahua Mountains years before. And I remembered an old black-and-white photograph I'd seen of a little girl in a bonnet sitting on top of a dead jaguar in front of a Tucson saloon. But that was the extent of my knowledge about borderlands jaguars. And I couldn't be certain whether I'd seen a puma or a *pantera*. If I hadn't seen the tracks, I'd have sworn I'd seen a ghost in the darkness. Whatever it was, it was gone. Pffft.

I don't give the sighting much thought for another week. I am headed for Aravaipa Canyon 250 miles north, crossing open ground that doesn't give up its secrets willingly. I've come to see a forgotten country and the lay of the land in between, where a seventy-thousand-square-mile archipelago of mountain islands floats high above the desert seas. The best way to do that is on foot. Many others have done this before me. Álvar Núñez Cabeza de Vaca came into this country in the 1530s after wrecking his ship off Galveston, Texas. Leading an entourage of followers across the continent, the conquistador-turned-medicine man turned south through these "mountains in the sun" and ended his extraordinary seven-year journey in Culiacán, Sinaloa. The trail that de Vaca blazed through the strange land called America and the tales that he told lured legions of Spanish explorers, padres, soldiers, and colonists who changed the face of the landscape forever. It was the home of the Apache for hundreds of years.

They did not give up without a fight.

I am dogging the trail of Geronimo. No one knew this country better. During a guerilla war that stretched hundreds of miles south from the Chiricahua Mountains deep into Mexico's Sierra Madre, Geronimo and a fleet-footed band of thirty-eight Chiricahua Apaches swept across an inland sea of knee-deep gramma grass on foot and on horseback, striking American troops with deadly hit-and-run raids before melting into the

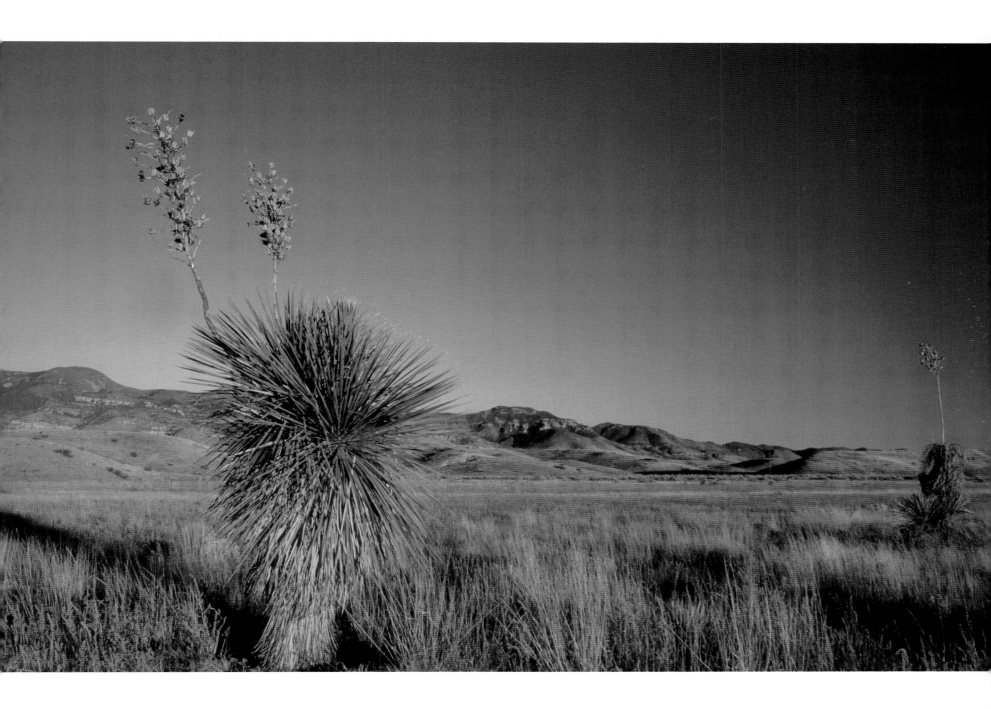

landscape. But the valiant war they fought could not turn back the tide of American soldiers, settlers, and bad men who also came into the country.

Two days north of the border, I climb high into the thin air and partly cloudy skies. I am weary from carrying a heavy pack across the broken landscape. And I am light-headed from the altitude—nearly ten thousand feet above sea level. But I can see how easy it was for the Chiricahua to escape, concealed by bosques of mesquite, then woodlands of juniper and oak that gave way to forests of Ponderosa and Chihuahuan pine that crowned the emerald summits of their namesake peaks. Perched on a rocky promontory, Chiricahua lookouts had a commanding vantage of government troops patrolling the valleys far below, a "stupendous panorama out over mountains, valleys, hills, and canyons thousands of square miles in extent." I can also see that southeastern Arizona, the Bootheel of New Mexico, and the Madrean highlands of Mexico finally lie at my feet. I take a deep breath, drop my heavy load of water and food, and lie down in a soft bed of pine needles. I doze off to the sound of the cool wind whistling through the treetops.

I am in good country, cut off from the bad. And I enjoy the hushed silence and peace of mind.

Bordered by the upper Rio Grande, Arizona Territory, and Old Mexico, the Bootheel is *mal pais,* "bad country." So is the country that lies in ambush around it. Italian hermit Giovanni Maria Agostini-Justiniani came into the country from the east. He lived in a cave at the foot of a mountain, where he prayed and healed the sick until he was found murdered, "lying face down on his crucifix with a knife in his back." Manuela Pavla Blanca de Luna came into the country from the south. She searched for her lost love, who had been killed by "Apaches," but the white sands her ghost first haunted never let her go. Don Miguel Peralta tried fleeing the country from the north. He reaped a mother lode of gold, but four hundred of his men died from the bloody curse of Spanish gold. "*Ni para mí, Ni para el diablo*": If I can't have it, the Devil can't have it, either.

The Bootheel itself was the domain of a lawless breed of men. Among the cutthroats and dry gulchers who worked the border, few were worse than Tombstone, Arizona is notorious Clanton Gang. They slaughtered nineteen Mexican smugglers during a raid in the Animas Valley for their cache of "$75,000 in Mexican silver." The smugglers who survived vowed revenge, and showed no mercy when they ambushed and murdered Old Man Clanton and four gang members in nearby Guadalupe Canyon.

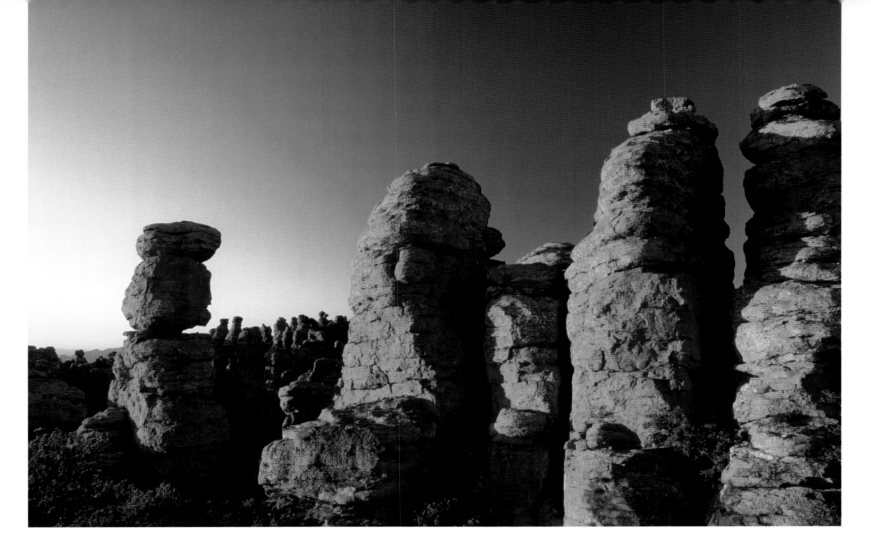

It still is bad country. There is no escaping its past.

Sitting alone atop my mountain lookout, I watch Chiricahua fox squirrels scamper up and down the Chihuahuan pines. And it is difficult to believe that the trails of Chiricahua Apache, conquistadors, and pioneers, and the game trails of grizzly bear, Mexican *lobo*, mountain lion, mule deer, and antelope, which thrived in the marvelous landscape of "sky islands," has been used by all manner of men, violent and humble, rich and poor, where the devil and God himself fought over their souls.

In 1989, not far from the seven strands of barbed wire that were strung piano-wire

Geronimo and his fellow Chiricahua often sought refuge in the mystical landscape (ABOVE) *they were said to have called "Land of Standing Up Rocks"* (NEXT PAGE).

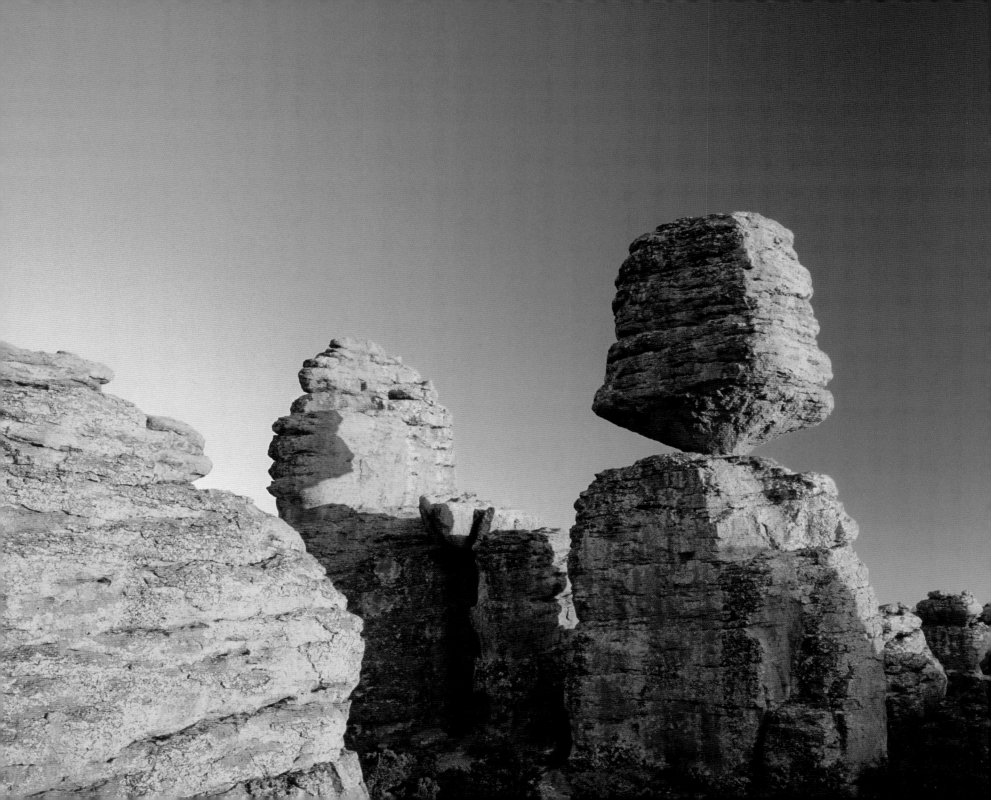

tight across the Chihuahuan Desert grasslands of the United States–Mexico border, thirteen people were murdered and mutilated, stuffed in a well, and covered with lime by drug dealers. But the stench of rotting corpses carried by the hot wind over the border town called Agua Prieta, "Black Water," could not be ignored. Neither could the tons of drugs that poured virtually unchecked through Agua Prieta, Sonora, and Douglas, Arizona—or the tens upon tens of thousands of desperate immigrants who fled their *patria* for the dreams and promises that awaited them across the wire. *En el nombre sea de Dios,* "In the name of God," many of them managed to survive the punishing sixty- to seventy-mile journey on foot across the desert, rocks, and prickly pear cactus to reach Interstate 10, where they were pushed north to distant cities of Chicago, Denver and Los Angeles. Hundreds of others perished in the footsteps of Geronimo and the Chiricahua Apache from heat stroke, snake bites, bitter cold, and flash floods. Many were hunted, beaten, and shot by American ranchers and vigilantes. Others who had whispered and prayed *"Que La Virgen Morena de Guadalupe nos ampare"* screamed and whimpered when they were robbed and victimized by smugglers, coyotes, and outlaws.

That was then—and so it is now. Only the future can tell if it will ever end.

I shoulder my pack and walk down the narrow trail deep into the woods, through "miles of magnificent forests interspersed with lush wildflower meadows and groves of quaking aspen." I am on the Chiricahua mountain trail, and it leads through country found nowhere else in the borderlands. It is a haven for tropical Mexican birds like the Elegant Trogon, the Holy Grail for bird-watchers, white-tailed deer, black bear, spotted rattlesnakes, coatimundi, and all manner of researchers studying the dynamics of a "biological sky island" that links the temperate climate species of the Rocky Mountains with subtropical species of Mexico's Sierra Madre.

I camp alone that night beneath a buttress of rock called Cochise Head in a fearfully lonely canyon named Indian Creek. It is unnaturally dark. I am beyond the reach of heavily armed smugglers who prowl through the San Simón Valley to the east, and I am beyond the help of tourists who marvel at twenty-seven-million-year-old rhyolite spires that form the geological wonders of Chiricahua National Monument to the west. I am on my own. The hoots of a screech owl and the sound of small birds flitting in brittle twigs and dry brush spook me with images of panthers and cougars.

Pursued by government troops across the San Simón Valley, Geronimo called on

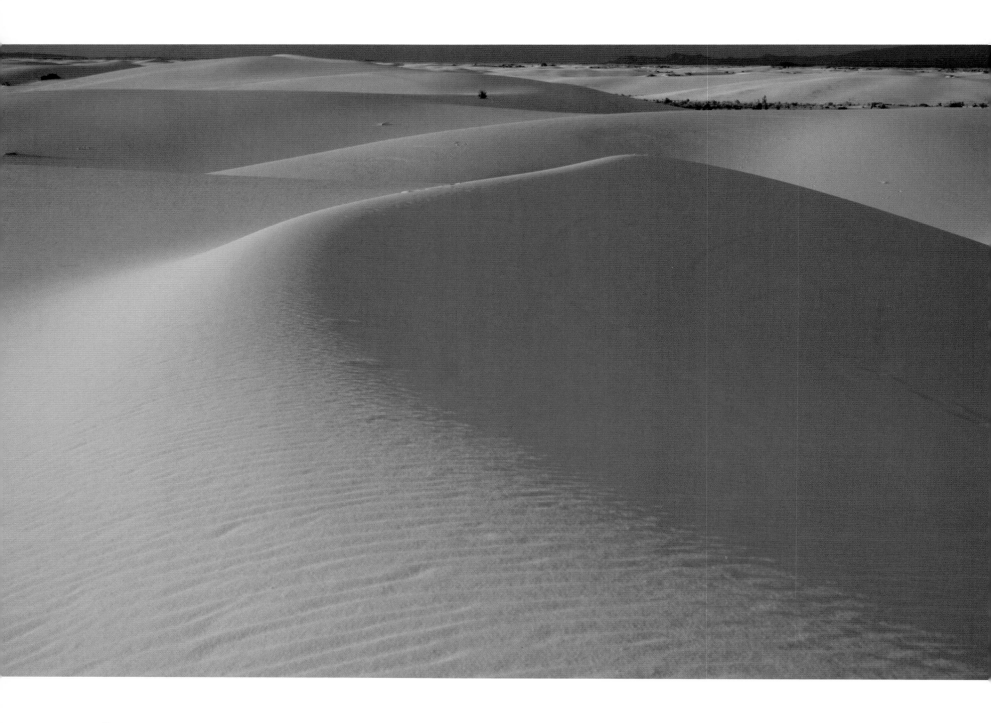

his Power one night to prolong the darkness so his warriors could escape into their stony sanctuary. I didn't know if his midnight passage lead through this black canyon, but throughout the "Apache Wars," Geronimo and the Chiricahua sought refuge in the mystical landscape that towered behind the ink-black rim above me. They were said to call it "Land of Standing Up Rocks." As I toss and turn on the cold sharp gravel, waiting for daybreak to come, that night is eternity for me, and I wonder if the shaman's words still prolonged the darkness. "So [Geronimo] sang, and the night remained for two or three hours longer. I saw this myself."

When sunrise finally winks over the canyon, my body is stiff and cramped. And my eyes feel like bull's-eyes. I beat back the damp chill with sweet black coffee brewed in a metal cup over a small, slow-burning fire of oak twigs. The day is a sleepwalk through the heat and humidity. I am tired and dehydrated and only stop for a cursory look at Fort Bowie, a military outpost against Geronimo, strategically built in "Apache Pass" between the Chiricahua and Dos Cabezas Mountains. My goal is to reach a food and water cache beneath Dos Cabeza Peaks before sundown. All I want to do is sleep.

But I don't reach the five-gallon jerry can of water until nightfall. I build a fire, cook a tried-and-true staple of macaroni and cheese, garlic, and green chili, and wolf it down. I take off my boots, peel off my knee-length leather snake leggings, and crawl into my sleeping bag, hypnotized by the burning embers of my fire and the gentle heat on my face.

A deep, menacing growl stirs me from my slumber. I dismiss the sound as molten resin hissing in the coals of my campfire and turn over. The growl becomes louder. I wake up and stare at the cold stars. The growl becomes a scream. *Yeowww!* I sit up. Adrenalin surges through me. My heart pounds against my chest. I stumble to my feet, trip, grab my boots, and see the dark feline shape of a large cat perched thirty feet above me, silhouetted against the stars. I grab

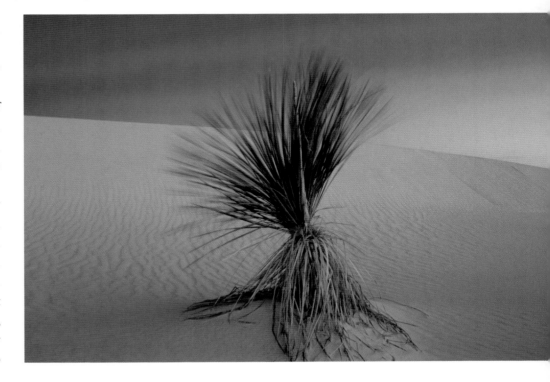

OPPOSITE: *The ghost of Pavla Blanca, White Sands National Monument, New Mexico. In search of her lost love, the ghost of Manuela Pavla Blanca still haunts White Sands* (BELOW) *five centuries after her husband, Hernando de Luna, was killed by "Apaches."*

RIGHT: *Lost Jesuit Gold, Superstition Mountains. No other mountains in the borderlands spawned as many legends as the Superstitions. When the Jesuits were expelled from New Spain in 1767, tales of the "Black Robes" hoarding gold from missions like* San Cayetano de Tumacácori *gave rise to beliefs that the "Lost Jesuit Gold" was hidden somewhere near this cross.*

OPPOSITE: *Peralta's gold, Superstition Mountains, Arizona. Once located in Alta Sonora, Mexico, the Superstition Mountains were a blessing and a curse for Don Miguel Peralta, who mined a mother lode of gold in his* Minas de Sombrero. *The 1854 Gadsden Purchase moved the new border a hundred miles south, and the 400-man Peralta Expedition was massacred by "Apaches" while making a run for Mexico with their last caravan of gold.*

60

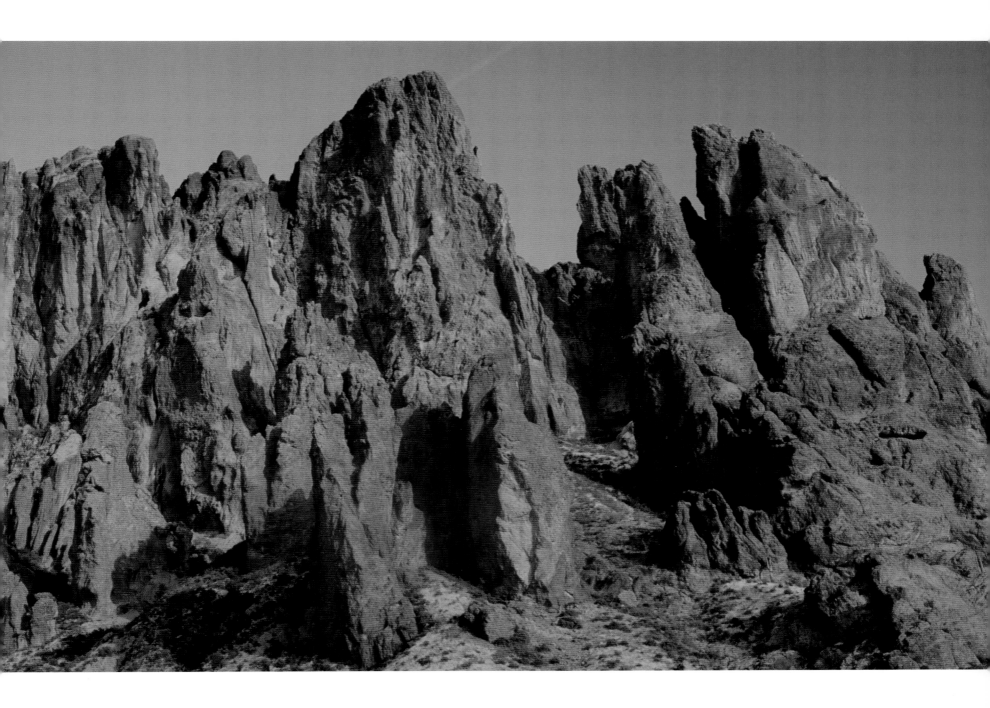

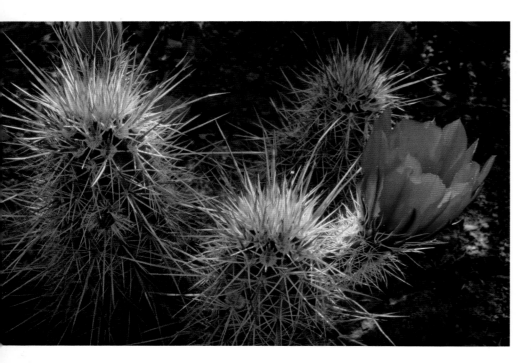

ABOVE: *Deadly beauty, Superstition Wilderness. No other American wilderness has proved as deadly as the Superstitions, which encompass 160,000 acres of soaring cliffs, rugged box canyons, and hoodoos of stone called Fingers of Fire.*

OPPOSITE: *Since the Peralta Massacre, more than 600 people have died from heat, cold, snake bites, and murder. Almost all—man, woman, and child—died while on the trail of cursed Spanish gold.*

my knife, though it won't be much good against a predator that survives by snapping the necks of deer in its jaws. I pile branches, limbs, and logs on the burning embers, and jump back as I toss a cap of white gas into the mix. The explosion lights up the night. The big cat screams, *Yeowww! . . . Yeowww!* Stranded alone atop the mountain, I have no place to run and no place to hide. I edge closer to the blaze, singeing my hair, and draw my knife from its scabbard. The big cat stands its ground. Its yellow eyes pierce the darkness and curdle my blood. Trembling with fear, I have no choice but to stand mine, clutching my knife and feeding the fire while the cat terrifies me screaming long into the night: *Yee-owww!*

I have returned to the Chiricahuas many times since that night. I didn't know why I wasn't attacked or if *el tigre* was a Mexican jaguar or an American lion. But when I returned in the fall of 2007, I found that much of the desert grasslands that had been partitioned out by the Spanish crown as land grants to settlers of New Spain is now ravaged and scarred by drug smugglers, immigrants, Border Patrol, vigilantes, and the makings of a steel border wall across the San Pedro River that ecologist Christine Haas said would be an "absolute barrier for all terrestrial wildlife." Much of the land, however, is being protected by ranchers and environmentalists who have joined forces. A step in the right direction, to be sure, but their holdings are locked up, gated, and walled off to everyday visitors who don't have access to the church keys.

The best of it, however, is the magnificent archipelago of mountain islands that still soars high above the man-made chaos that plays out in its desert seas. "For these delectable sky islands," wrote naturalist Weldon F. Heald fifty years ago, "provide an . . . escape hatch from the increasing pressures of modern civilization." Fortunately, it's still possible to find refuge in the high peaks of the Pedregosa, Chiricahua, and Dos Cabeza Mountains, where you're more likely to stumble into the frightening lair of a mountain lion or border-lands jaguar than into the deadly haunt of smugglers bristling with guns, greed, and murder.

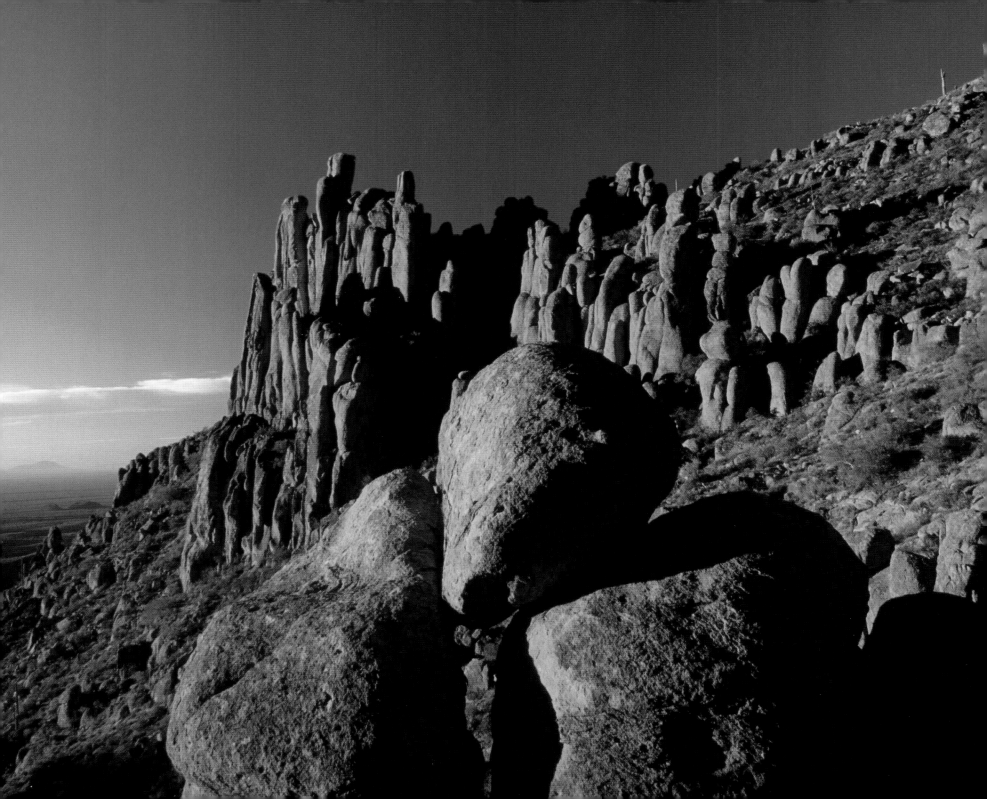

RIGHT: *Charros, Valle del Sol, Arizona. Re-introduced to North America by conquistador Hernán Cortés in 1519, horses were used by* charros, *"horsemen," and missionaries to establish presidios, missions, and haciendas throughout Mexico and New Spain.*

OPPOSITE: Charro *traditions passed down over the generations still flourish on haciendas, Spanish land grants, and ranches throughout the borderlands five hundred years after Cortés vanquished the Aztecs.*

64

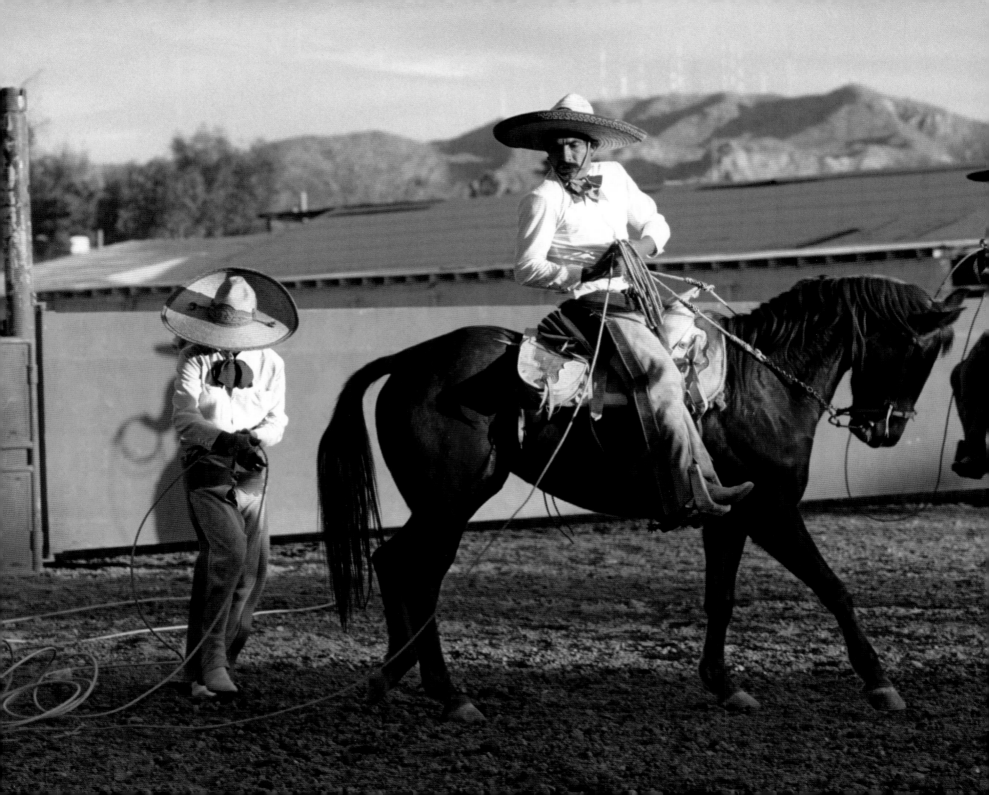

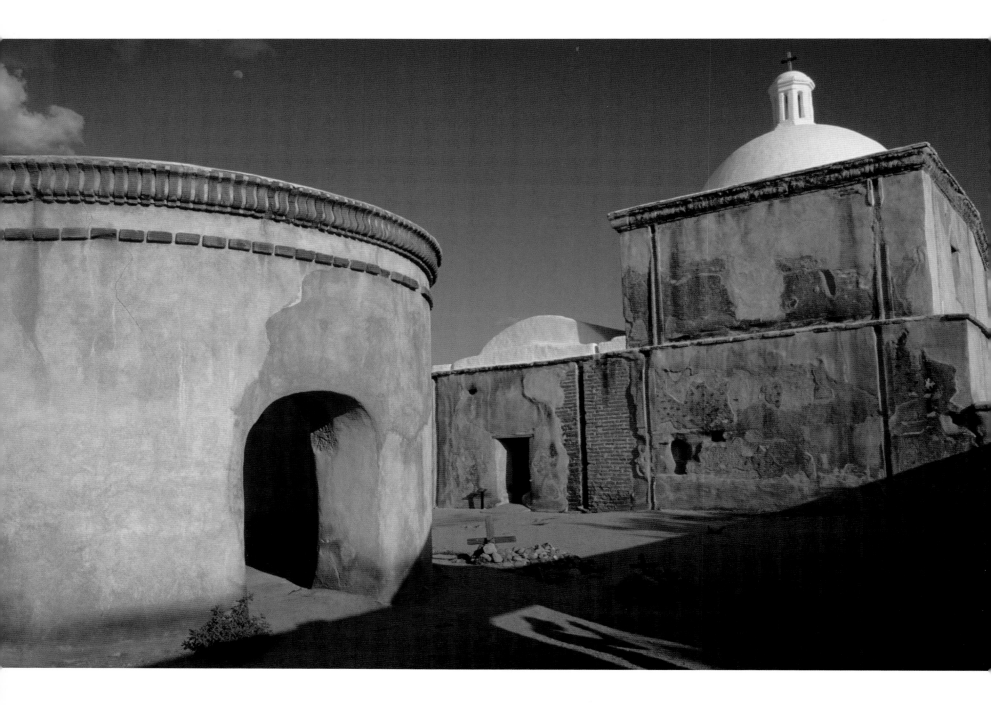

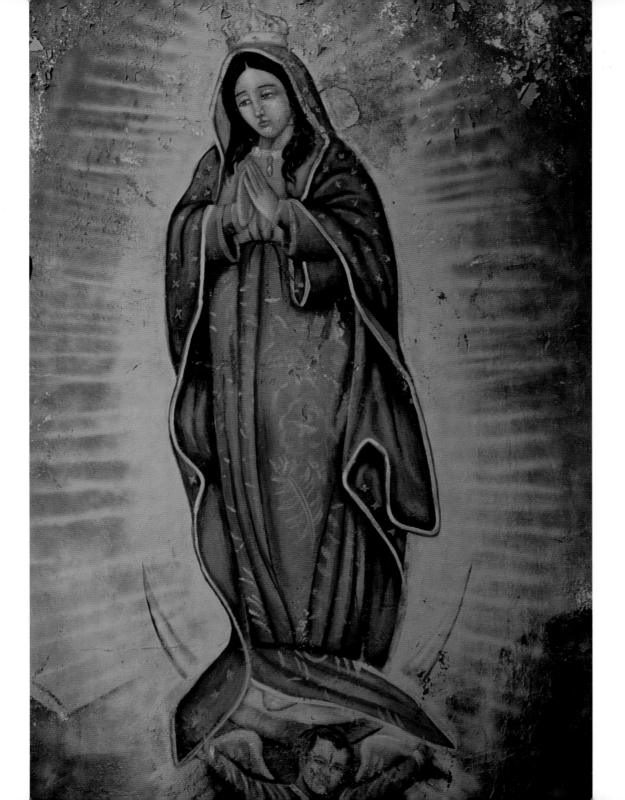

OPPOSITE: *Mission, Tumacácori National Historic Park, Arizona. Established by Jesuits as* Misión San Cayetano de Tumacácori *in 1701, it was one of many missions built in* Pimería Alta, *"Upper Pima Lands," to Christianize Pima, Papago, and Ópata. When the Jesuits were banished from New Spain, Franciscans built* Misión San José de Tumacácori.

LEFT: La Virgen de Guadalupe, *Miguel Ángel Grijalva mural, Arizona. Revered in Mexico since her miraculous apparition appeared before Juan Diego on Tepeyac Hill in 1531, La Virgen de Guadalupe adorns historic adobes, churches, and roadside shrines throughout the borderlands.*

City of Rocks, Bootheel, New Mexico. Formed thirty-five million years ago, the house-sized boulders of Kneeling Nun Tuff offered shelter for the ancient Mimbreño people between 750 and 1250 A.D. (OPPOSITE) *They scratched out a meager living on the northern fringes of the Chihuahuan Desert.*

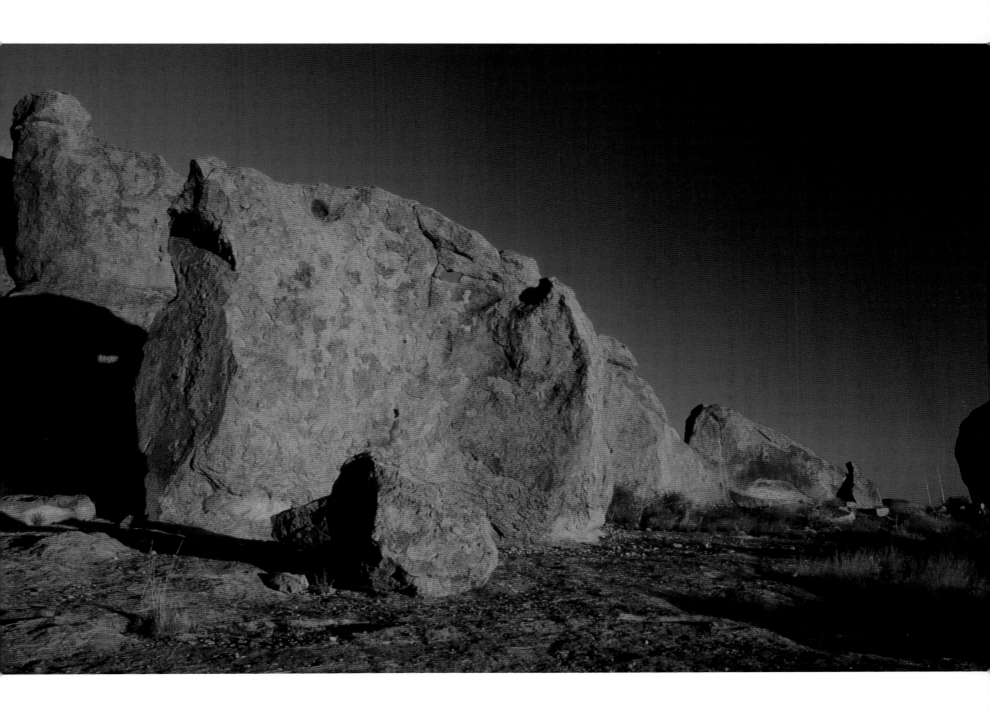

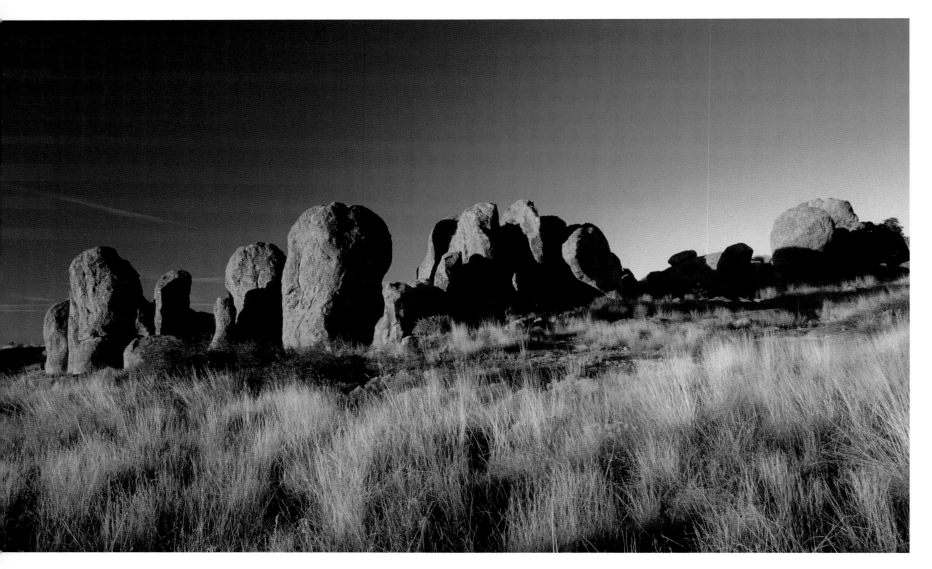

Spanish Landmark, City of Rocks, New Mexico. The landmark stones were a reliable waypoint for Colonel Manuel Carrasco, who in 1804 hauled copper ore across the borderlands from the Santa Rita Mines to supply the Spanish royal mint in Mexico City. (OPPOSITE) *Yaqui Trail, Atascosa Mountains, Arizona. On the run from Mexican troops, 150 Yaqui warriors fled north across the border in 1927. "Apprehended" by U.S. Border Inspectors, the heavily armed Yaquis were given political asylum and, in 1964, granted sovereignty on American soil.*

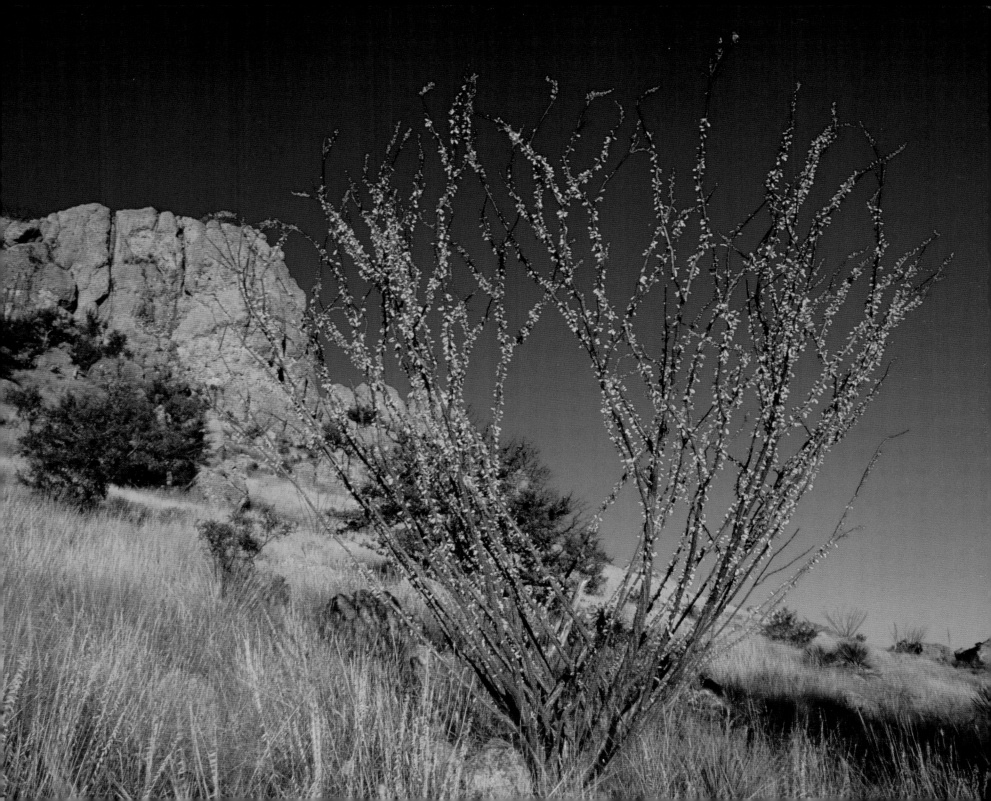

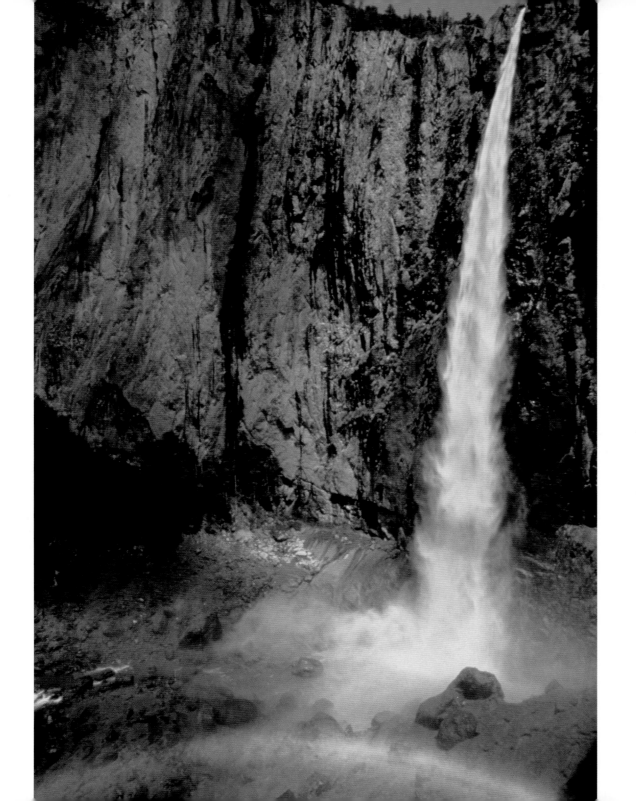

OPPOSITE: *Vanishing Homelands, Tiger Lily, Chihuahua. The stunning terrain of the Sierra Madre Occidental is the homeland of the Tarahumara, Mexico's largest, most traditional indigenous group.*

LEFT: *Basaseachi Falls. Throughout their history, the Tarahumara migrated deeper into their rugged barrancas to flee the scourge of smallpox, "Apaches," and American scalp hunters.*

73

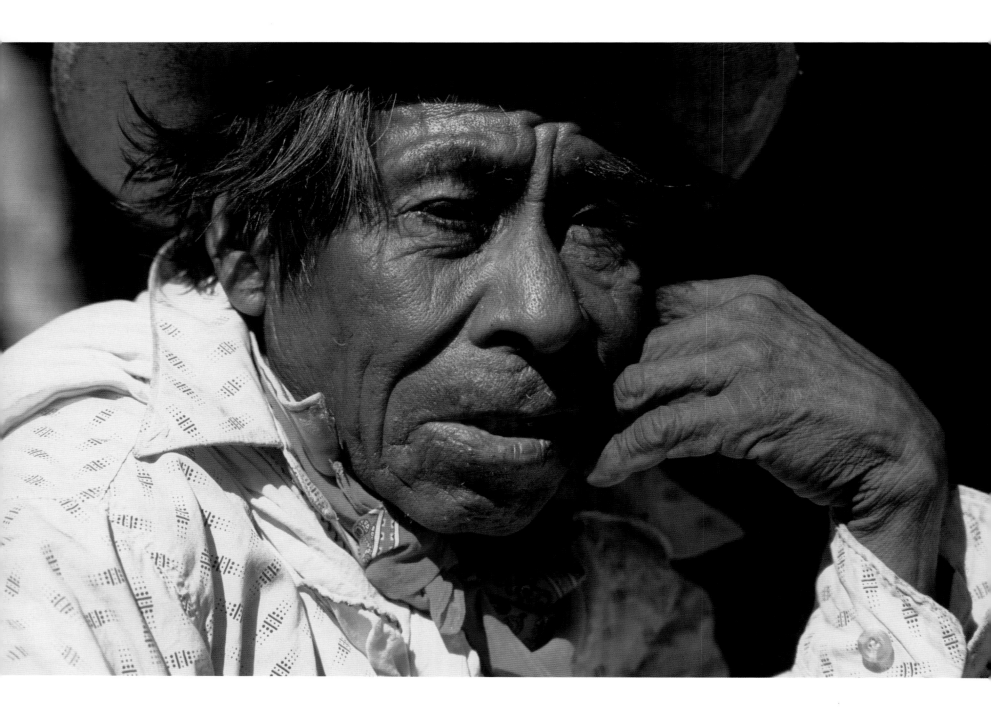

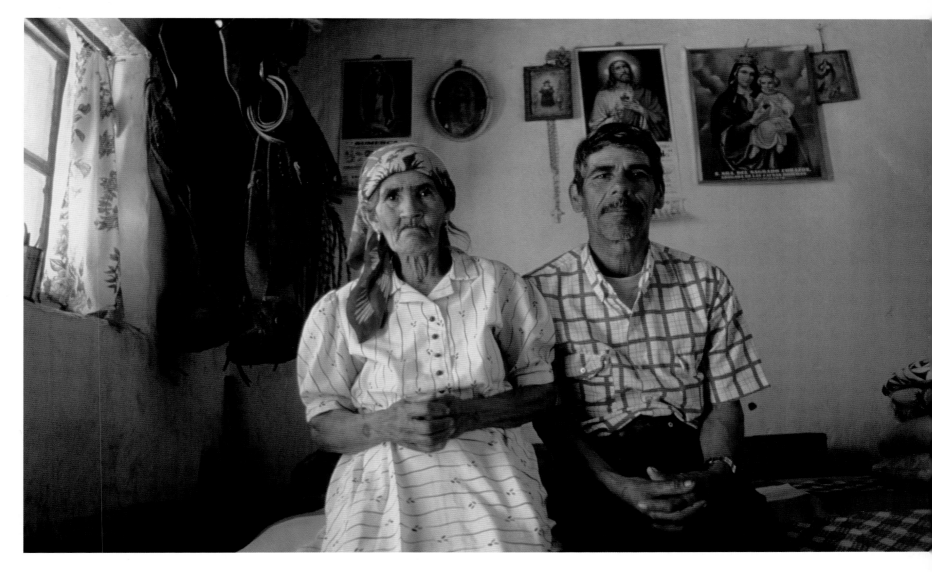

OPPOSITE: *Displaced by commercial deforestation, drug cultivation, and a quarter million Mestizos living in the Sierra Madre, many Tarahumara have fled the drought and violence that has wracked their homelands for poverty-stricken* colonias *in the border cities of Ciudad Juárez and Ojinaga.* (ABOVE) *Mestizo blood, Chihuahua. Antonio González Ortíz and his wife, Cenona Monje, endure life in the* monte, *"mountains," without electricity.*

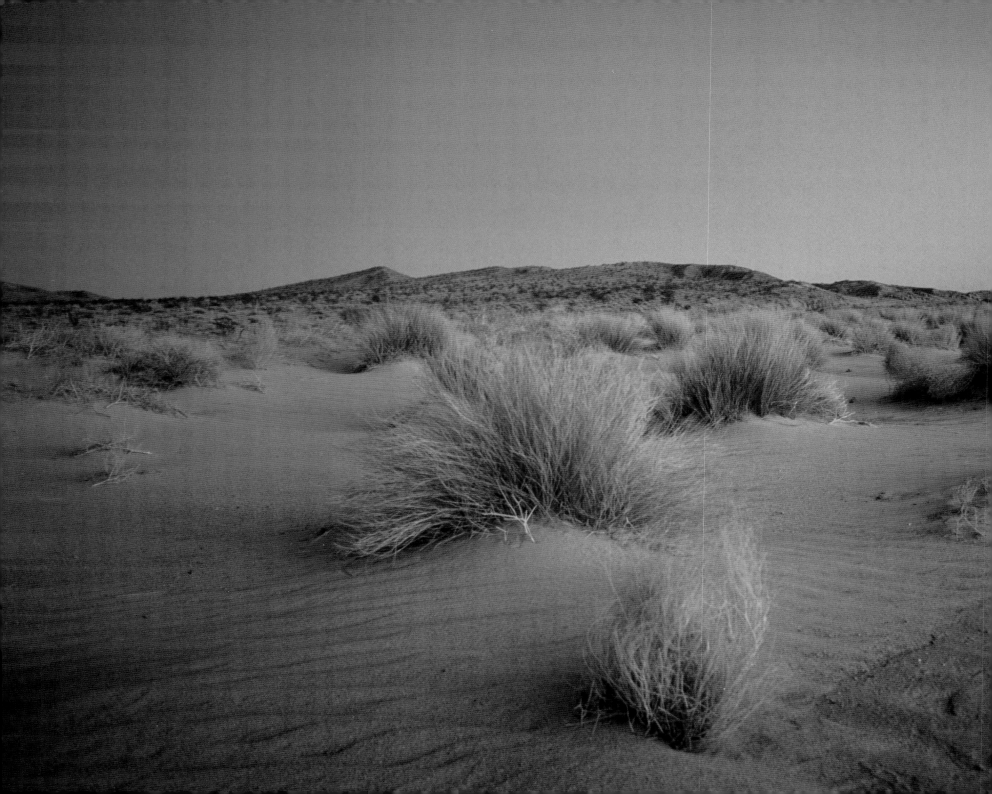

salida

Passing Through

SOUTHEAST CALIFORNIA, SOUTHWEST ARIZONA AND
SONORA AND BAJA CALIFORNIA NORTE, MÉXICO

Another phenomenon peculiar to the desert . . . is the mirage,
seemingly formed merely to mock the dying traveler with visions
of unlimited water, which he craves above all else on earth.

— CAPTAIN DAVID D. GAILLARD
EL CAMINO DEL DIABLO, 1896

DUSKY MOUNTAINS ERUPT FROM A SILENT SHEEN OF DESERT THAT STANDS BRILLIANT
against powder-blue skies. It's 112 degrees, and little attention is given to the extraordi-
nary scenery that engulfs our tiny shadows. We are lost in an immense landscape that en-
compasses the most beautiful and deadly desert in North America. It stretches one hun-
dred miles south from the Gila River to the Sea of Cortés, and one hundred twenty miles
west from the Sierra del Ajo to the Colorado River. We are walking west through a five-
thousand-square-mile no-man's land toward a shimmering playa that recedes as we ap-
proach. We have been chasing a mirage of fresh water we crave more than anything else on
earth. But for every step we take toward it, it moves equidistantly away. Spring toward
the gray reflection, it springs away. Stop, it stops. Step backward, it moves forward. We
can't touch it anymore then we can nab our fleeting shadows, which float across the hot
caliche, coarse gravel, and wind-blown sand like mummies. Migrants who perished out here
after being rescued by the Border Patrol have been called "the walking dead" because their
brains overheated and cooked before their core temperature could be chilled with ice.
We keep moving, monitoring each other with each guzzle of hot water that we force
ourselves to drink.

I came here to walk 130 miles in the sandal tracks of New Spain's greatest explorers,

hoping to glimpse what it may have been like for Kino, Anza, and Garcés to cross this country during the 1700s. And I wanted to taste what Forty-Niners, *gambusinos,* and thousands of Mexican immigrants endured crossing their trail midsummer. I lusted to see this grand desert on foot, and I longed to learn the Camino's secrets that lay dormant for more than a century. Two others were struck by the same wanderlust and insisted they join me. At first glance, we are an unlikely trio. Bruce Lohman is a helicopter pilot based at the Marine Corp Air Station in Yuma. He oversees search-and-rescue operations for pilots training in the Barry M. Goldwater Range. Increasingly his mission includes saving immigrants stranded in the bombing range. David R. Roberson is a fixed-wing pilot based at the U.S. Border Patrol sector headquarters in Yuma. His mission is to apprehend "illegal aliens," but he's found his greatest rewards saving their lives. I met them both while covering the largest rescue in the history of *El Camino del Diablo,* "the Highway of the Devil," when U.S. Marine helicopter crews and Border Patrol agents from DART (Desert Area Rescue Team) joined forces to save 22 Mexican immigrants from the San Cristobal Wash's valley of death.

We have been walking since daybreak in hopes of putting the interminable *jornada* behind us. In spite of periodic rest stops and the five gallons of water each of us is carrying between Papago Well and Tule Well, it's impossible to drink enough water to keep walking across this punishing swath of Sonoran Desert. We have entered the killing ground of the burning black scoria of the Pinacate Lava flow and the ankle-burning talc of the Pinta Sands. Moisture evaporates from our bodies faster that we can replenish it. We have to stop before our core temperatures red line in the furnace heat.

We set down our water jugs, drop our packs, and tie a thin white bed sheet between the flimsy branches of two creosote bushes. Huddling beneath the pitiful shade, it offers little relief from the scorching sun that burns through the cotton veneer. The ground temperature hovers between 140 and 160 degrees. People who've fallen down in this skillet and lived to tell their tale had to be treated for first- and second-degree burns. We insulate ourselves by sitting on bedrolls that act as hot pads. But there is no escaping the radiant heat that wicks moisture from our bodies with each breath. We can do nothing but wait—and evaporate—until the air temperature hints at dropping below 110 degrees. It's 1:30 P.M., and that will take some time.

We have been following the tracks and narrow wagon ruts of California-bound Forty-

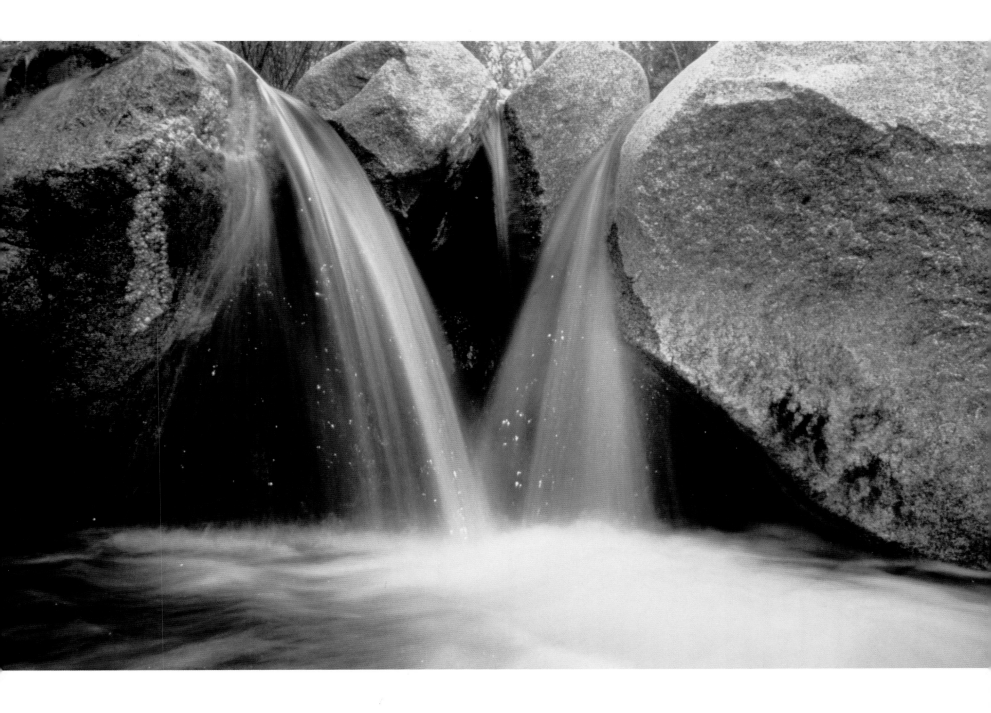

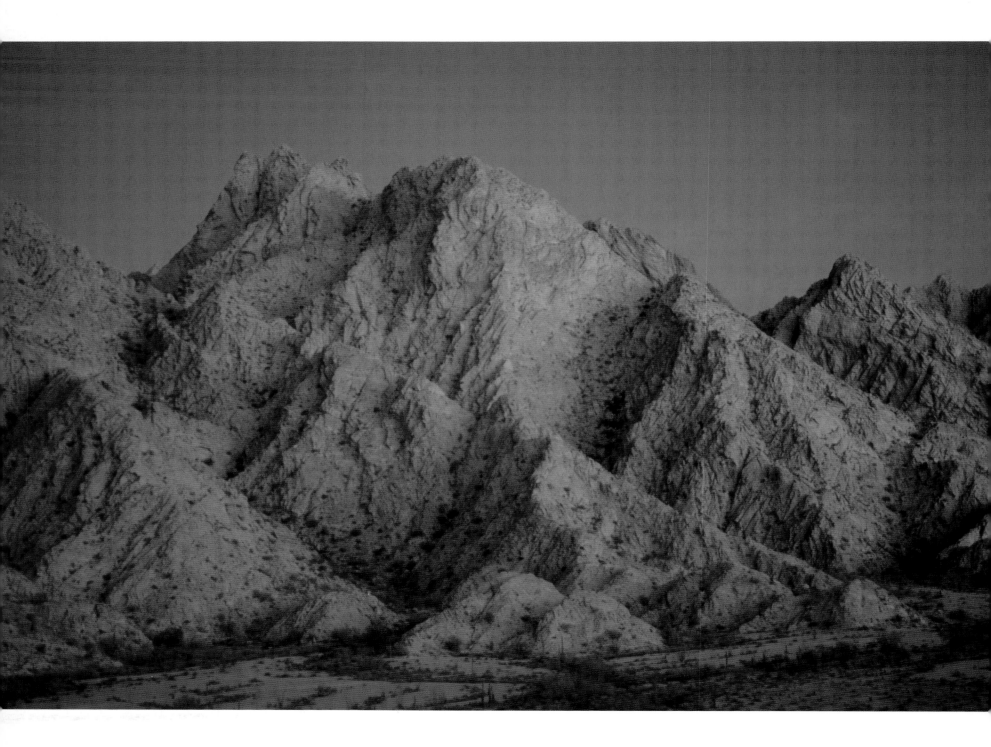

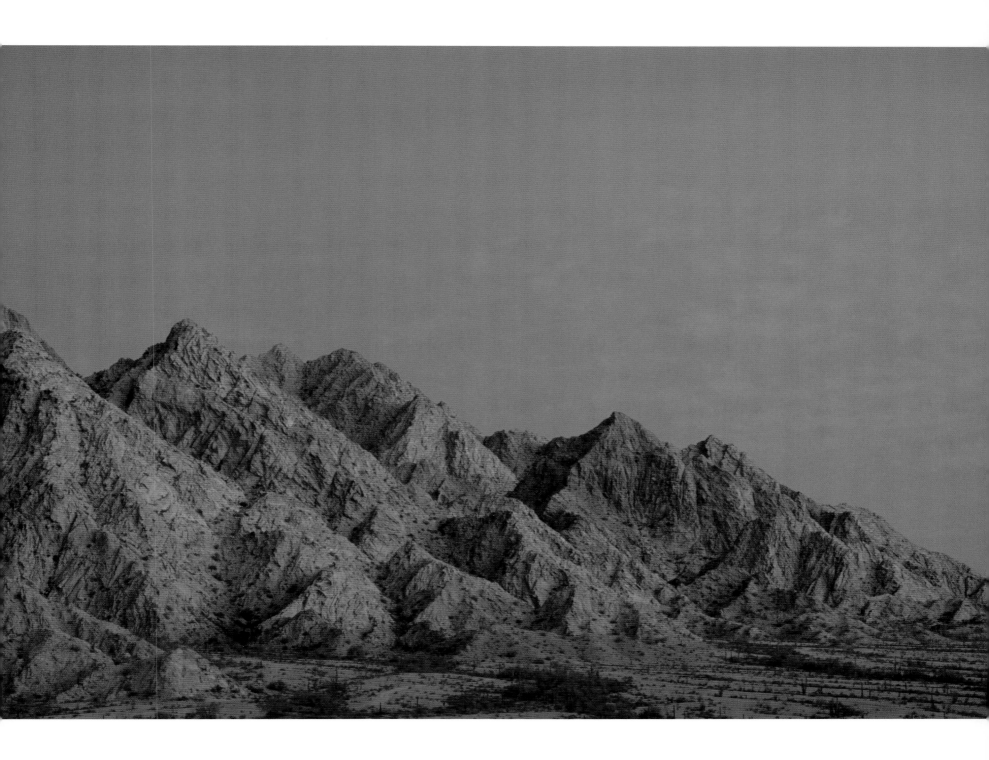

Dawn panorama, Tinajas Altas Mountains, Arizona and Sonora, Mexico. During 1849–1850, hundreds of California-bound Forty-Niners, gambusinos, *and immigrants died at the foot of the rugged border range trying to reach trying to reach its life-saving waterholes.*

Niners, Mexican *gambusinos* (prospectors), and immigrants from both countries who wagered their lives that they could cross the 130-mile wide inferno between Sonoyta, Sonora, and Yuma, Arizona. For three days we traced the infamous trail that meandered through a hypnotic sweep of granite mountains, clawing out of a mirage of desert valleys that has also proven to be a terrible killing ground for unsuspecting Mexican immigrants. Only the most tenacious plants, animals, and people can survive the appalling heat and extreme aridity and await the miracle of moisture that sometimes kisses these desert bajadas with life. Mistletoe growing on eight-hundred-year-old ironwood trees sustain crested flycatchers called Phainopeplas with hundreds of berries they eat each day instead of drinking water. Juicy spine-covered red fruit of the saguaro, prickly pear and organ pipe cactus once provided the nomadic Sand Papago with a moveable feast of food and beverages they ate and drank while foraging and hunting during the deadliest days of summer. When and if monsoons bless the scorched earth, bursage growing amongst the panoply of creosote, coyote melons, and chain fruit cholla cement fragile biological soils when sheets of rain sweep down alluvial fans and arroyos that drain ancient mountains soaring nearly three-thousand feet above.

This remarkable transborder bioregion, we also find, is home to black-tailed jackrabbits that mock our clockwork three-miles-an-hour progress by loping and bounding across the horizon in front of us. Coyotes, gopher snakes and prairie falcons compete for pocket gophers, kangaroo rats, and whiptail lizards. Turkey vultures that loom large in the fiery ball of sun feed off the carrion that all too often includes people who succumbed to thirst or sidewinders we dance around with less finesse than roadrunners that prey on the deadly pit vipers. Desert tortoises burrow underground to escape the summer heat until the desert cools, but the coo-cooing of mourning doves and the music of songbirds alerts us to the promise of water and redemption just over the horizon. Much like Phainopeplas, the endangered Sonoran pronghorn antelope and desert bighorn sheep also have adapted without drinking water by processing moisture from the browse they eat.

The only people who dwelled in what pioneers cursed as hell on earth were the *Hia Ced O'odham,* "People of the Sand." Never numbering more than several hundred, the Sand Papago roamed the Empty Quarter of southwestern Arizona and northwestern Sonora on a never-ending quest for food and liquid they harvested from a cornucopia of mesquite beans, cactus fruit, sand roots, desert spinach, chuckwallas, iguanas, Gambel's quail, pronghorn

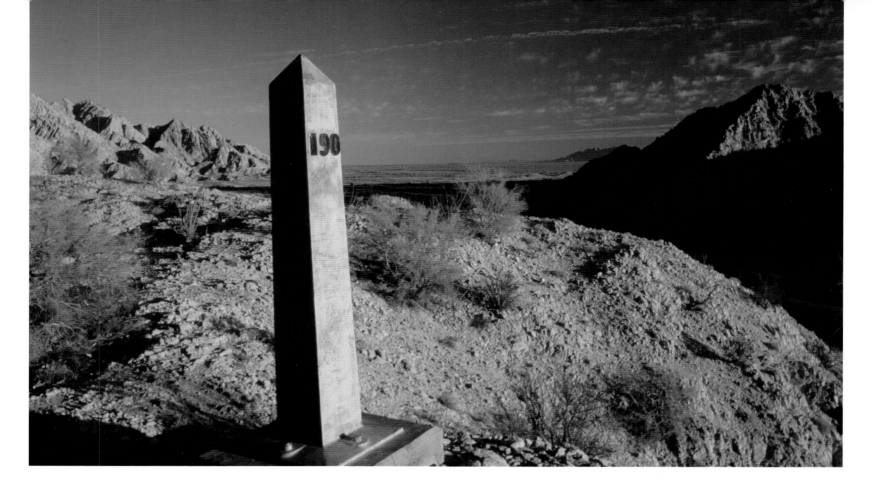

antelope, bighorn sheep, sea bass, shrimp, sea turtles, and a host of other natural foods that sustained them in one of the harshest deserts on earth. Everyone else was just passing through—*if* they could survive the journey.

Many did. The largest sand sea on the continent lies just south of where we huddle beneath our creosote awning, and it has fomented apparitions of a mysterious Lady in Blue. During the Spanish Inquisition, Franciscan mystic María de Jesús de Ágreda vowed she'd had hundreds of trance-induced "bilocations" from Spain and ministered to Indians in the borderlands of Texas, New Mexico, and Arizona between 1620 and 1631. Church investigators did not want to believe such raptures or heresy, but the Jumanos of New Mexico confirmed they'd been taught by "the Woman in Blue." Many thought the venerable nun was killed by Yuma Indians in 1605; others pray she'll be beatified as a saint. Some

United States–Mexico Boundary Monument 190, Barry M. Goldwater Range, Arizona and Sonora, Mexico. Following the 1848 Treaty of Guadalupe Hidalgo, the 1,956-mile border was surveyed by joint expeditions under the U.S.'s William H. Emory and Mexico's José Salazar y Larregui.

The surveyors marked the new boundary with 258 cast-iron obelisks, an extraordinary six-year-long effort that required hauling, manhandling, and erecting the heavy six-foot tall columns in some of the most dangerous terrain in North America.

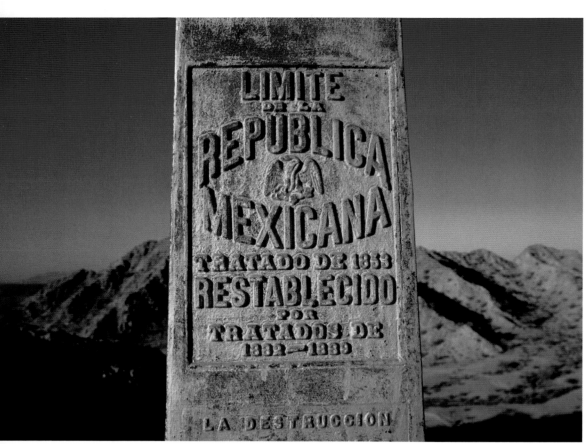

believe her benevolent spirit floats in the mirages we've been chasing for days to protect penitents who still travel the Devil's Highway.

Many did not survive their journey along the paths of the Sand Papago that linked ancient water holes which offered pioneers their only chance of escaping the deadly grip of the Devil's Highway. Called the Old Camino Real, Las Rutas de Kino, Rumbo El Sahuaro, Sonora Trail, Sonoyta-Yuma Trail, Old Yuma Trail, Hell's Highway, and Highway of Death, *El Camino del Diablo*—"The Highway of the Devil"—was the name that finally stuck. For good reason. During the height of the California gold rush, from 1849 through the 1850s, an estimated four hundred to two thousand people died crossing the Camino del Diablo.

It was "a record," the United States–Mexico Boundary Survey said, "probably without parallel in North America."

At 3:30 P.M. my companions and I stagger to our feet. Our legs are cramped, and our faces are covered with salt. But a faint breeze exhales across the desert from the Sea of Cortés. We continue west along a trail that many still swear God forgot and see the first of several mileposts that mark the Camino. A puzzling stone alignment I assume is a grave marker reads: NAMEER 1871. We shake our heads in the midday sun. Nothing else is known about Nameer. His fate and identity remain an enduring mystery in the annals of Camino del Diablo, distinguished for such tales on the National Register of Historic Places.

Down the road a day and a half later, we come to another mysterious grave. It's a large stone circle with a figure 8 in the middle of it. Of the scores of crosses and graves that once marked the Camino's dead-

liest stretch between the "Circle of 8" and the life-saving water of *Tinajas Altas* ("High Tanks"), none has a more tragic story than the Mexican family of eight who died of thirst in 1864, when the glass demijohn holding their water supply broke while being unloaded from their wagon. The father went looking for water to save his wife and children, but to no avail: "Weak and faint, he returned from his unsuccessful search and joined his dying family under a neighboring palo verde tree, where their bodies were all found by the next traveler and buried in a single grave along the road. Pious hands had piled stones on the grave in the form of a cross, and had encircled the whole by a ring," Captain Gaillard wrote.

Some believe the stone line that now runs through the Circle of 8 is an arrow pointing west toward the Tinajas Altas Mountains that shimmer in distant heat waves. It takes us nearly two hours to finally reach the rugged border range, and we are beat from the morning's brisk seventeen-mile walk in the oppressive heat. Bruce lies down in the shade of a palo verde tree. His sunken eyes mirror dehydration and visions of untold others who died at this very spot. "Many made the dreaded journey in safety. . . . Some perished of thirst by the way, some wandered from the road and never found the water which they craved, some reached the tanks, but, finding the water all gone and too weak to go further, lay down and died," the intrepid Gaillard reported.

Bruce forces down the hot, putrid water from his canteen and covers his face with a wet bandanna while Dave and I go for fresh water. We climb up steep rock slabs to a natural rain basin in a hanging granite gorge and drink cool water until our stomachs are full. Cooled by the shade and breeze, I peer through the canyon window at the trail that snakes across the Lechuguilla Desert, Cabeza Prieta, Tule Desert, Sierra Pinta, and Agua Dulce Mountains ninety-one miles east to Ajo. It has taken us four days to cross what had also been the haunt of Edward Abbey. His fondness for the desert was revealed in his writing: "Off in the distance, as everywhere in this desert land, rose the arid mountains, all rock and angles sparsely grown with brush, floating under cloud shadows, dappled with sunlight, colored by superstition and legend. I imagine them full of lost gold mines, sun-bleached skeletons of men and horses. . . ." Off in the distance, Abbey found peace in his beloved desert, where he was buried amidst the arid mountains by a friend. Many followed the echoes of Abbey's voice into "the last great treasure in the Continental United States." And during their sojourns, they resurrected the vision of Secretary of Interior Stewart L. Udall, who first proposed linking Organ Pipe Cactus National Monument, Cabeza Prieta

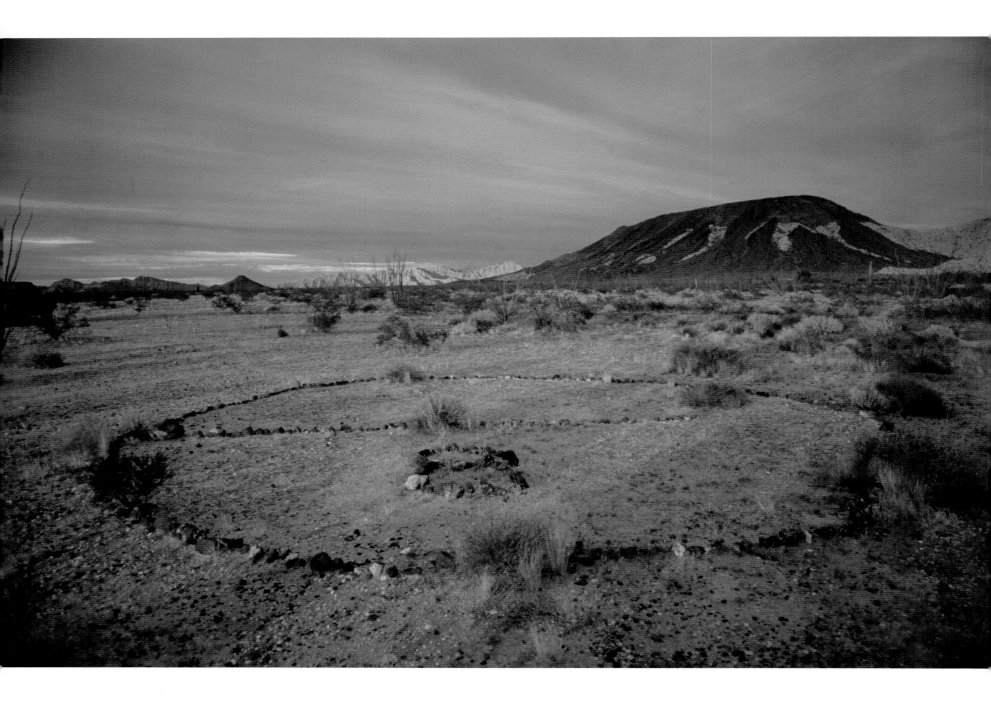

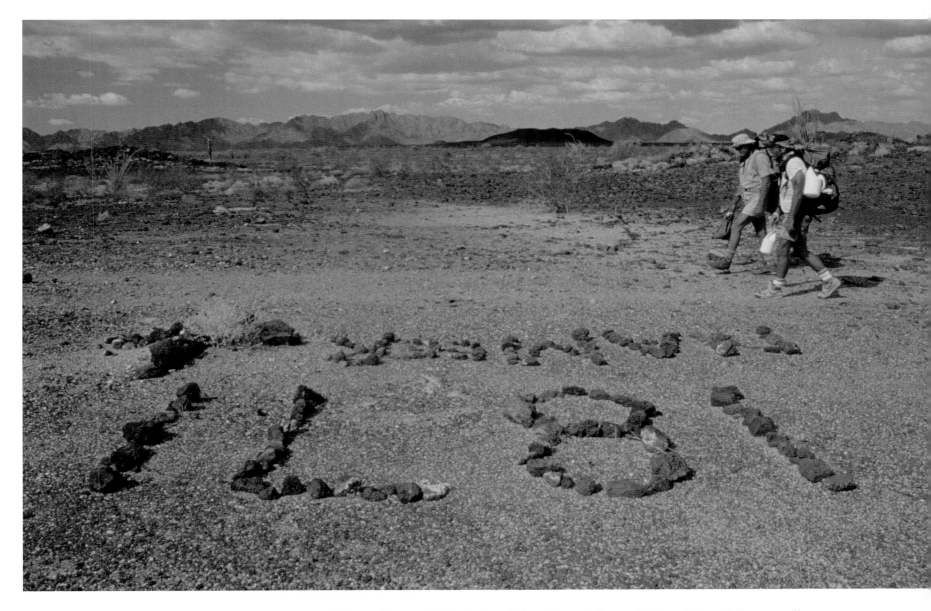

Nameer's grave, 1871, Cabeza Prieta. Bruce Lohman (left) and Dave Roberson walk past Nameer's grave during a 130-mile summer trek across the Camino del Diablo. (OPPOSITE) *Circle of 8, Cabeza Prieta National Wildlife Refuge, Arizona.*

National Wildlife Refuge, and the Barry M. Goldwater Range into one magnificent sanctuary called Sonoran Desert National Park. It would have been the linchpin for "the greatest transnational biological reserve on earth," one writer wrote, because it would also include the alluring desert lands, river, and sea south of the United States–Mexico border. The conservationists had seen the bodies of our neighbors strewn across the landscape on the evening news, and they'd seen firsthand the destruction of the fragile landscape. But none foresaw 9/11 and the politics of terror and immigration that would kill their dream.

Sated by shade, water, and the prospect of fulfilling a dream of crossing the Camino del Diablo on foot, I couldn't predict the forces that would destroy the vanishing borderlands that the Camino linked together. Nor would Edward Abbey likely recognize the ravaged landscape his beloved desert now resembles in its hardest-hit areas. It is a land under siege. High-speed off-road pursuits between smugglers and Border Patrol Humvees have created a 1,200-mile labyrinth of wildcat roads that wind through tow darts, abandoned vehicles, drone airstrips, migrant foot trails and trash, and Border Patrol drag roads, pullouts, and outposts of Camp Grip and Bates Well. But the destruction could not stop the slaughter. Four thousand one hundred brave souls have sacrificed their lives in search of the American dream, crossing the borderalands under the Border Patrol's watch since they launched Operation Gate Keeper in 1994; most of them died slow, agonizing deaths from dehydration. Among the most tragic sagas were thirteen Salvadoreños and fourteen Veracruzanos who tried digging for water with their fingertips before perishing from madness and thirst in the killing grounds of Organ Pipe Cactus National Monument and Cabeza Prieta National Wildlife Refuge. Who knows how many whispered the words of "*Mexico Lindo y Querido*" before they took their last breath and slept forever in the hot sand: "*Mexico lindo y querido si muero lejos de*

ABOVE: *A relic of the past, Goldwater Range. Aviation archeologists learned from this serial number that an F14 Tomcat fighter jet based off San Diego on the carrier USS Kitttyhawk crashed in the borderlands on February 28, 1983. Both pilots ejected safely.*

OPPOSITE: *Tow Dart, Pinta Sands, Barry M. Goldwater Range. Strafed during air-to-air sorties, a thousand or more 14-foot-tall DARTS (Deployable Aerial Rigged Targets) remain unrecovered in the Sonoran pronghorn's refuge.*

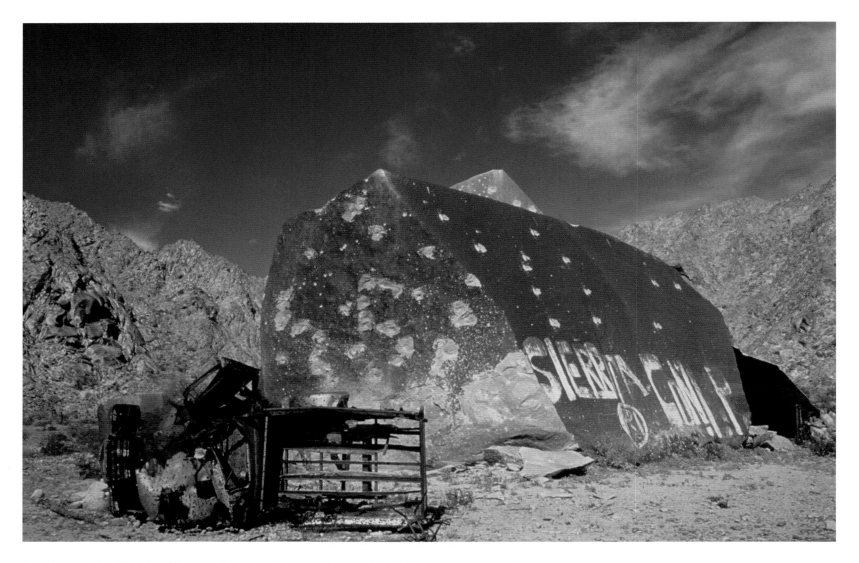

No Country for Old Men, Pinacate Biosphere Reserve, Sonora. Riddled by heavy arms and cannon fire, a landmark boulder and bombed-out truck mark a remote aeropista, *"airstrip," used by smugglers south of the Cabeza Prieta.* (OPPOSITE) *Under siege, Roger Di Rosa, Cabeza Prieta National Wildlife Refuge Manager. Buried in the Cabeza by a friend, with "ten circling buzzards" soaring above, author and environmentalist Edward Abbey would not recognize the ravaged landscape of his beloved desert today. Roger Di Rosa has fought to preserve the Cabeza Prieta's fragile beauty.*

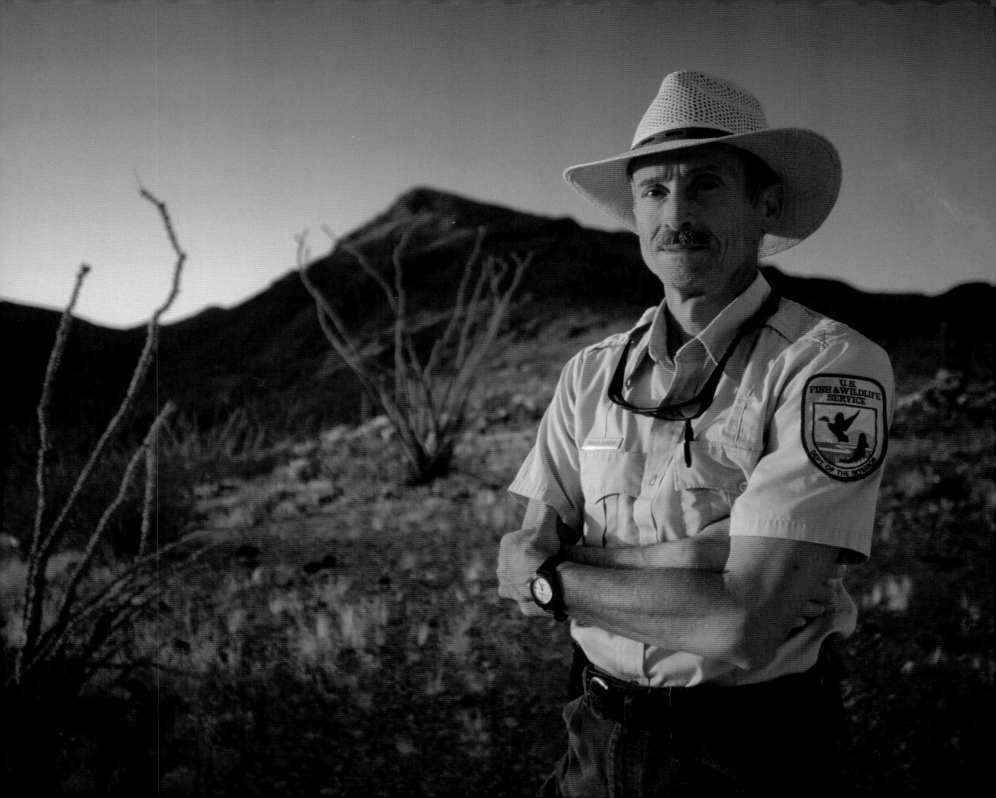

Colorado River, Imperial National Wildlife Refuge, Arizona and California. Nearly depleted by upstream demands before it trickles into the Sea of Cortés, the lower Colorado River is the border between Arizona and California and the Mexican states of Sonora and Baja California Norte.

tí, que digan que estoy dormido, y que me traigan a tí" ("Mexico, beautiful and dear, if I die far from you, they'll tell you I'm sleeping and bring me back to you").

The Camino del Diablo itself is facing its own demise. In the Papago Well guest book, one disillusioned visitor wrote the old trail had become *El Camino de La Migra,* "the Border Patrol Highway." To accommodate heavy Border Patrol traffic the proposed eighteen-foot widening and resurfacing of the most famous trail in America will be the death of the Camino del Diablo. Across the border, south of the Cabeza Prieta, many remote *aeropistas,* "airstrips," used by smugglers have been destroyed by Mexican soldiers who gouged deep, intaglio-

sized serpentine ruts in creosote-specked bajadas of desert pavement that will not recover for hundreds of years—if they recover at all.

It takes several trips for Dave and me to manhandle eighteen one-gallon jugs of water from Tinajas Altas down to the *Mesita del Muerto,* "Little Mesa of Death." At one time sixty-five graves marked the deaths of gambusinos and forty-niners who perished trying to climb up to High Tanks. A Marine to the bone, Bruce will not be among them. It's 5:15 P.M. when we finally stagger out of the graveyard, carrying six gallons of water each for the forty-mile long *jornada* to reach Interstate 8.

Based on historic maps, the leg of the Camino del Diablo we're following also was used by one of its most colorful and dashing figures. Joaquin Murrieta and his wife crossed the *Rumbo El Sahuaro* in 1850 en route to *Alta California,* "Upper California." Murrieta prospected in the California goldfields until his wife was murdered by Americans who resented Mexican miners. Murrietta avenged his wife's death, and a bounty was put on his head. Heads rolled, but they weren't Murrietta's. He escaped and fled south through the borderlands, running herds of stolen horses across the Camino Real, Camino del Diablo, and Gran Desierto into Sonora singing the words, "*¡Todo o Nada!,*" ("Everything or Nothing!") His life and exploits earned him a reputation among paisanos as the "Mexican Robin Hood" who inspired the legend of Zorro.

It's 9:00 P.M. when we finally reach camp on a barren sweep of desert pavement called the Davis Plain. We spread our bed sheets on the flat, rocky ground and turn in. Watching shooting stars streak across the heavens, I'm mesmerized by the stellar beauty and a silence broken occasionally by the distant rumble of trucks and buses traveling Mexico's Highway 2. I count myself among the lucky few who have had the good fortune to cross the heart of this desert on foot. Yet, I have a humble longing for earlier days, when the world and all its maladies didn't come crushing down on our fragile planet and people who inhabit it. In *The Perils and Wonders of the True Desert,* I'd read: "Yet, in spite of all that has been said, there is an unexplainable fascination about the desert—a charm which, after awhile, everyone feels, and which causes one to look with longing for the time his eyes may rest upon the well-remembered scenes, and once more he may stand amid . . . soothing silence."

More than the heat, I still recall with fondness the enchanting days and nights I was charmed by the soothing silence and haunting beauty and grace of the Camino del Diablo.

Picacho Peak, Ninety-Mile Desert, Arizona. Picacho Peak marked the vicinity of Aquituni, *a mysterious water source discovered by Anza during his expedition across the desert in 1775–1776.* (OPPOSITE) *Smuggler's Corridor, Saguaro National Park, Arizona. Established by President Bill Clinton in 1994 to protect "forests" of Saguaro* (Carnegiea gigantea) *that provide habitat for Gila woodpeckers, American kestrels, and red-tailed hawks, the park is threatened by urbanization, pollution, and smugglers.*

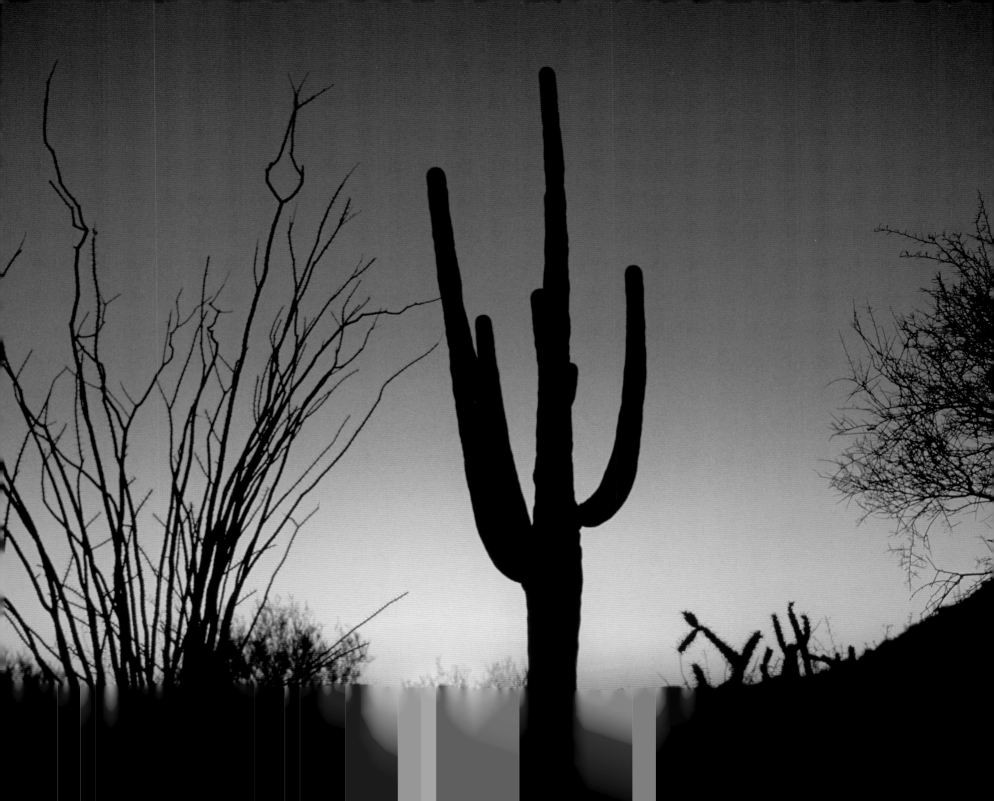

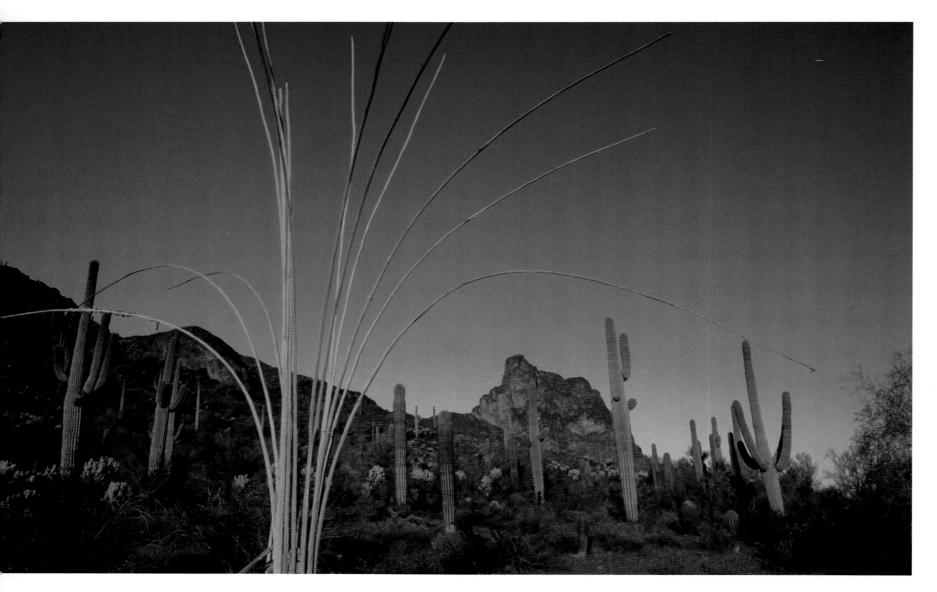

Ninety-Mile Desert, Arizona. The Ninety-Mile Desert was a daunting jornada *for Spanish explorers crossing the deserts of New Spain in the 1700s.* (OPPOSITE) *Wild saguaro, Organ Pipe Cactus National Monument, Arizona. Many colorful figures followed the Camino del Diablo's strange mileposts—none as popular as Joaquín Murrieta, who inspired the legend of Zorro.*

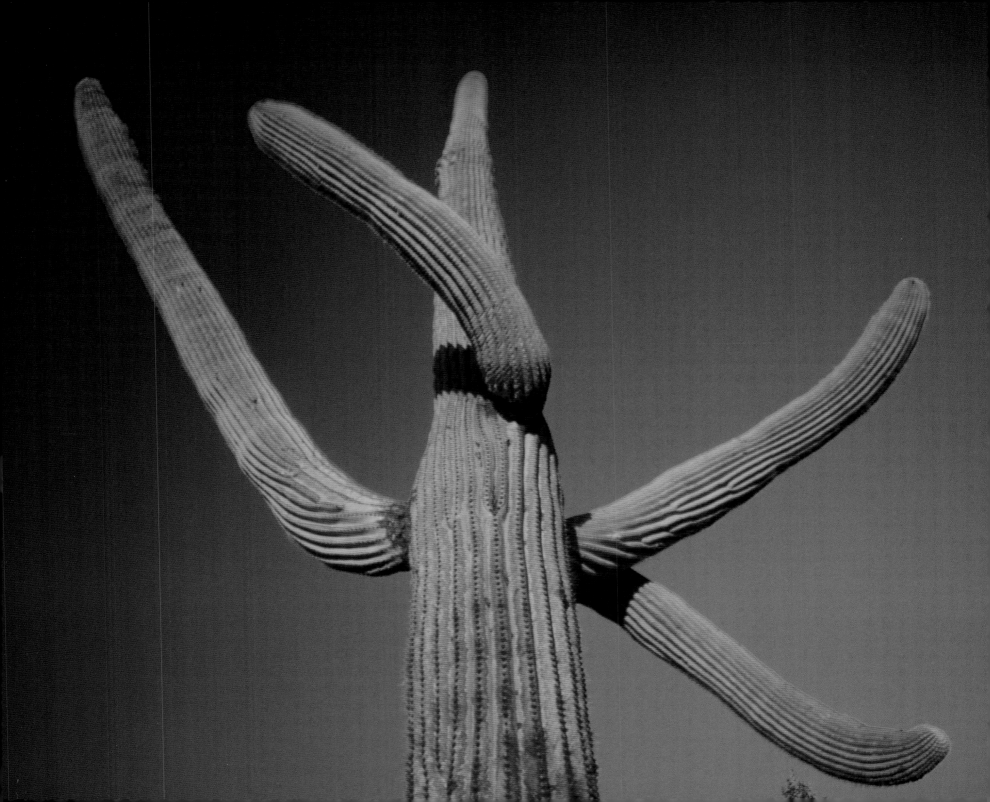

RIGHT: *Great blue heron, Upper Gulf Biosphere Reserve, Sonora. A great blue heron* (Ardea herodias) *flies over Mexico's 2.3 million acre biosphere reserve, established to protect endangered fish like the totoaba* (Cynoscion macdonaldi) *and Vaquita porpoise* (Phocoena sinus), *which have been decimated by industrial fishing.*

OPPOSITE: *Sea of Cortés, UNESCO World MAB Reserve. In his paean and environmental treatise* The Log From the Sea of Cortez, *Nobel laureate John Steinbeck (with marine biologist Ed Ricketts) witnessed the death knell of one of the world's great marine fisheries in 1941 as Japanese trawlers dredged the sea floor, "literally scraping the bottom clean," for shrimp* (Penaeus stylirostris and P. californiensis), *tossing overboard tons of sierras, pompano, sharks, tuna, and stingrays that "littered" the sea.*

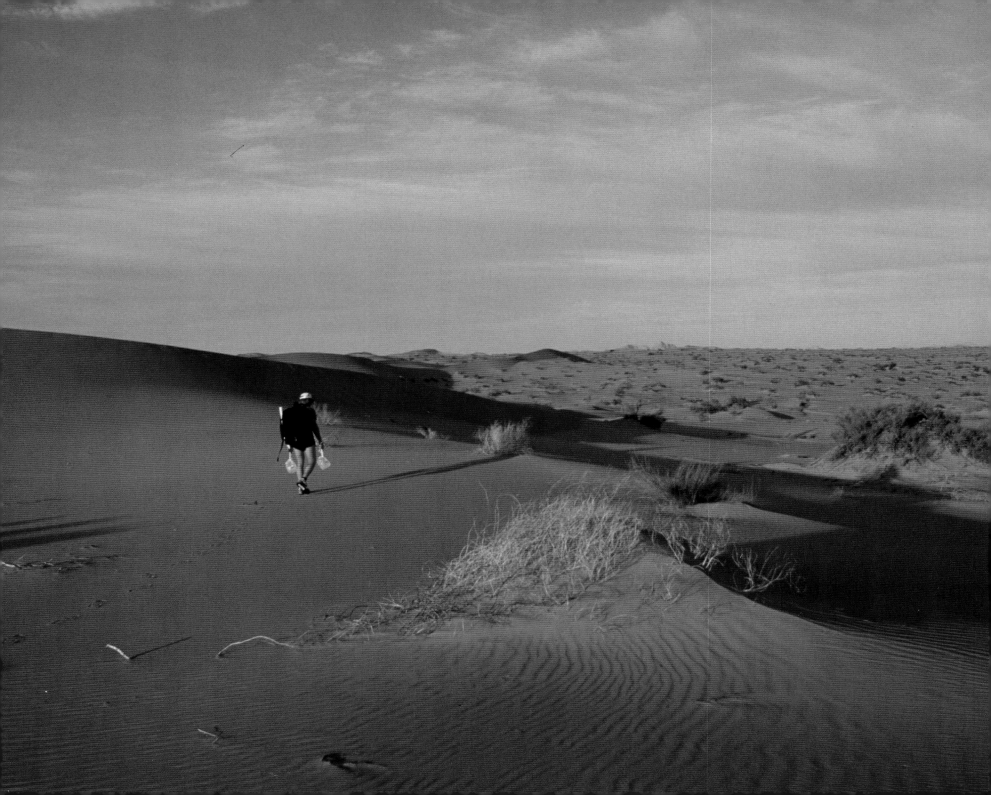

Mountain lion cubs, Reserva del Centro Ecológical de Sonora. *Established in 1988 to foster appreciation of the Sonoran Desert's biodiversity, the Ecological Reserve protects 65 species of birds and 154 species of mammals, including these rare lion cubs* (Puma concolor). (OPPOSITE) El Gran Desierto, *UNESCO World MAB Reserve, Sonora. Bruce Lohman enters the four-thousand-square-mile void of* El Gran Desierto. *The largest sand sea on the continent fomented apparitions of a mysterious Lady in Blue.*

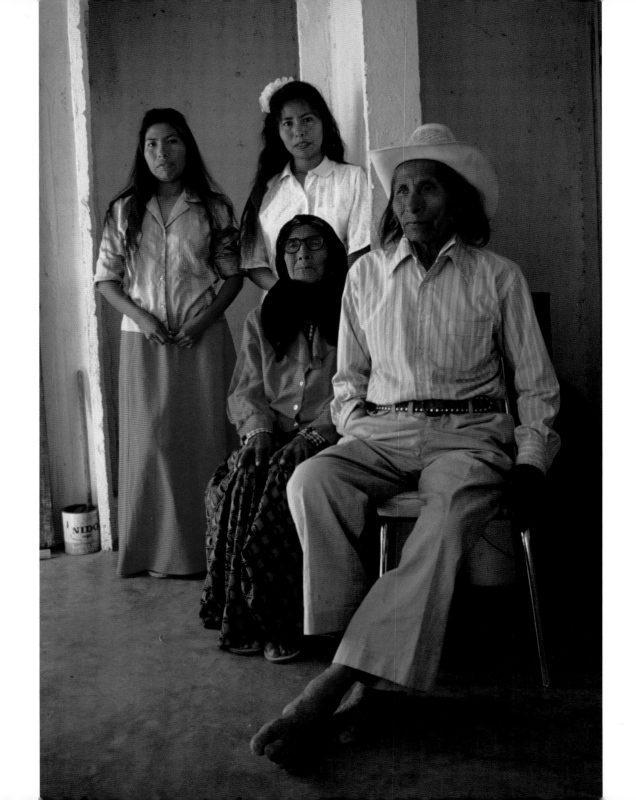

Molino family, at home on the Sea of Cortés, Sonora. Seri basket makers like Nora (standing, left) and Aurelia (standing, right) have found a vibrant market throughout the borderlands for exquisite hand-woven baskets (OPPOSITE) *that have commanded attention from Indian traders, American museums, and international art collectors.*

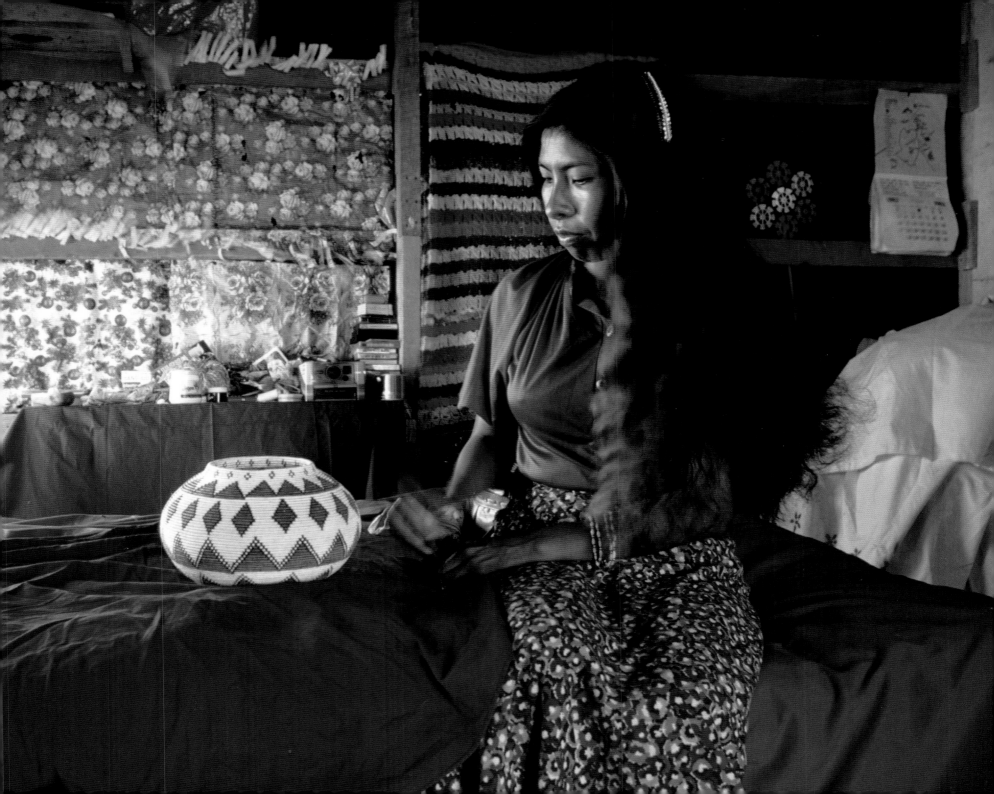

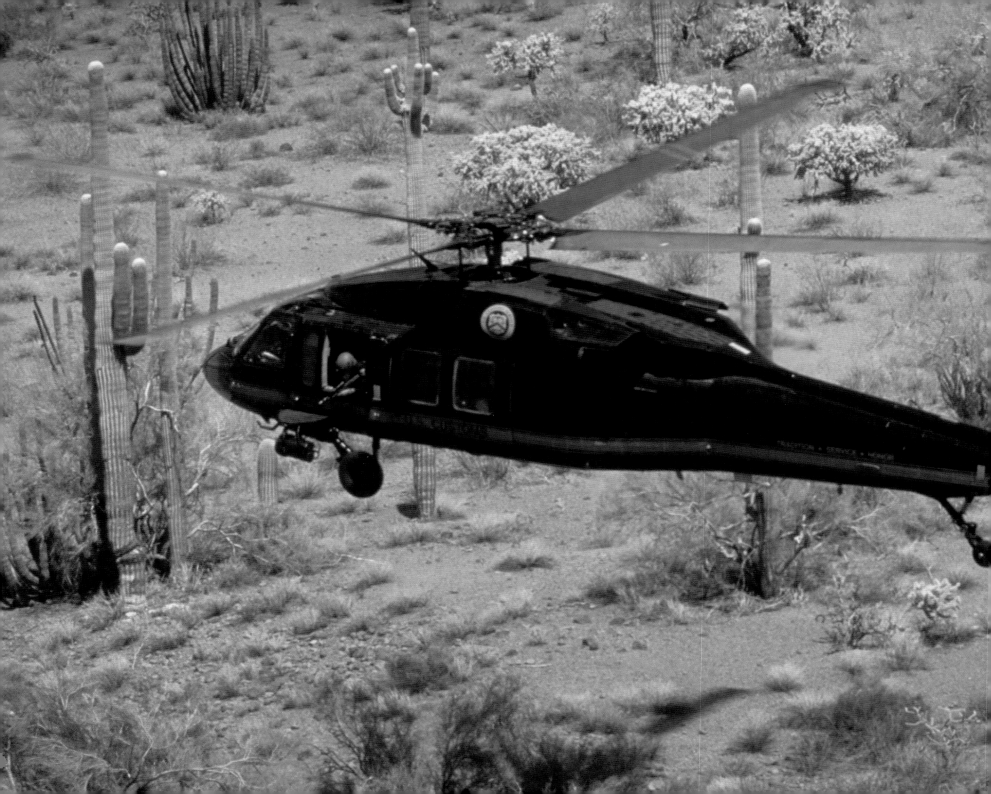

border wars

Tracking Smugglers and Coyotes in America's Most Dangerous Parklands

What's going to have to happen?" Camarena said miserably. "Is somebody going to have to die before anything is done? Is somebody going to have to get killed?

—ELAINE SHANNON
DESPERADOES, 1988

THE "BORDER WARS" MANY JOURNALISTS NOW REFER TO BEGAN WITH THE HEINOUS torture, murder, and disappearance of DEA agent and family man Kiki Camarena in Mexico in 1985—and they have not subsided. Camarena paid the ultimate sacrifice, fighting what author Elaine Shannon wrote was "the war America can't win."

Nor have the murders of American agents working the borderlands from Brownsville, Texas, to San Diego, California, abated. It's not a safe place. Sixteen Mexican journalists working the other side of the line from Matamoros, Tamulipas, to Tijuana, Baja California Norte also have been murdered or disappeared since 2000. For years that I worked alone in the borderlands, I was guided by an unflinching camera lens, the grace of God, and the words *No te he visto. No me has visto* ("I didn't see you. You didn't see me"). American law-enforcement agents have a different mandate, and in spite of state-of-the art weapons, air power, and backup, they've been frequently out-manned and out-gunned. One hundred and five men and women have died in the line of duty since Mounted Watchman Clarence M. Childress was gunned down by smugglers on the banks of the Rio Grande near El Paso, Texas on April 13, 1919.

As of this writing, Senior Border Patrol Agent Luis Aguilar has become the border war's latest victim. On January 19, 2008, the husband and father of two was run over

PREVIOUS PAGE: *Blackhawk patrol, Organ Pipe Cactus National Monument, UNESCO World MAB Reserve Arizona. On the trail of a dozen "backpackers" (drug mules), a U.S. Customs Blackhawk helicopter searches for suspects in a forest of saguaro cactus.*

RIGHT: *Lured by hopes and dreams of a better life in America, an immigrant family sits for a portrait in a Mexican bordertown, blissfully unaware of deadly hazards that await the innocent in the Arizona desert. The night before this photo was taken, witnesses told me they'd seen the bodies of a young mother and daughter who'd succumbed to freezing temperatures in the Arizona desert.*

OPPOSITE: *Door gunner, Blackhawk patrol, United States/Mexico border. An Air Interdiction Agent rides shotgun during a search and rescue mission that saved eight drug mules from dying of thirst.*

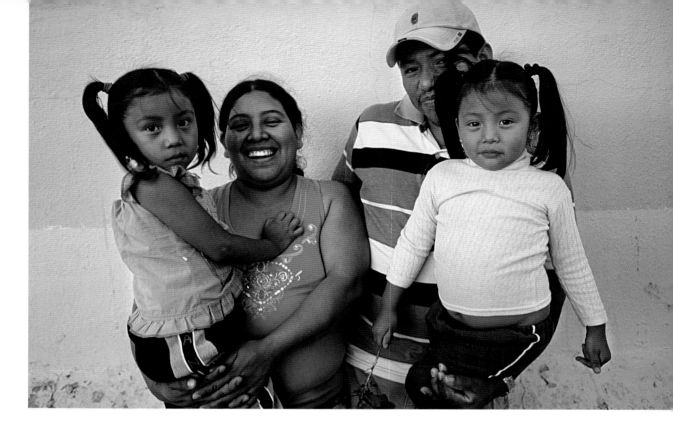

and murdered by suspected drug smugglers in California's Imperial Sand Dunes Recreation Area. Aguilar's tragic death is part of a violent pattern that emerged before National Park Ranger Kris Eggle was murdered on the border in Organ Pipe Cactus National Monument on August 9, 2002. Smugglers were no longer dropping their loads when faced by law enforcement agents. They were standing their ground, guarding their loads, and shooting back in deadly fire fights.

Nor were Mexican agents about to let Eggle's killer, Pánfilo Murillo-Aguilar, escape in spite of the 1911–1919 Revolutionary execution practice of *La Ley de Fuga,* "The Law of Flight," If a condemned man somehow escapes a firing squad's hail of bullets, he's free. Fleeing back to Mexico with his AK-47, Murrillo-Aguilar was riddled by multiple gun shots from what National Park Ranger Jon Young told me were "thirty to fifty Mexican police, Federales, and PJF *(Policia Judicial Federal)* shooting over the fence" into the United States. Despite Young's efforts to save Murillo-Aguilar, he died before he could be evacuated by helicopter. Eggle's murder sounded the alarm for Congress to green

light Organ Pipe's $14 million, twenty-nine-mile long vehicle barrier—the lever for legislating the 2006 Secure Fence Act.

The Secure Fence Act did not prevent Agent Aguilar from being cut down in front of American tourists in the Imperial Sands. The fence did not deter the smugglers who recently breached the border wall with portable SUV ramps to reach California's Interstate 8. And there's little reason to believe *coyotes* won't reopen a sealed border for desperate migrants by taking their cue from network broadcasts on *Televisa* and *TV Azteca* of Palestinian demolition experts blowing up the border wall separating the Gaza Strip from Egypt to survive. Nor will vehicle barriers stop—or hold the Mexican government accountable for allowing—the unconscionable slaughter of more than 4,100 immigrants who've perished from thirst, heat, and cold crossing the line on foot under the Border Patrol's watch since Operation Gate Keeper was implemented in 1994. Agents, immigrants, indigenous people, locals and the borderlands natural wonders are locked in the crosshairs of a war that America still hasn't won.

POSTSCRIPT: As this book goes to press, twenty-two-year-old Mexican national Jesús Navarro Montes was arrested for the murder of Border Patrol Agent Luis Aguilar. It's not known if Mexican authorities took the suspect into custody as a sacrificial *chivo expiatorio* (scapegoat) under international pressure to clean up a high profile incident, or if he's the real killer.

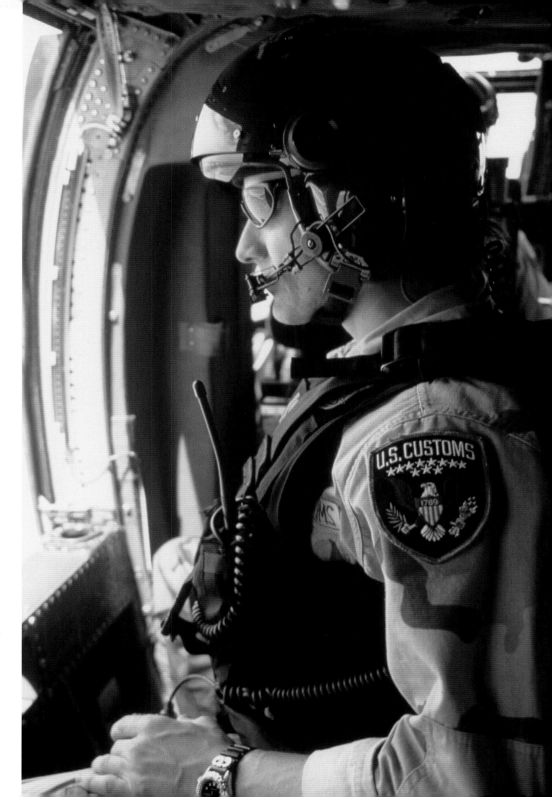

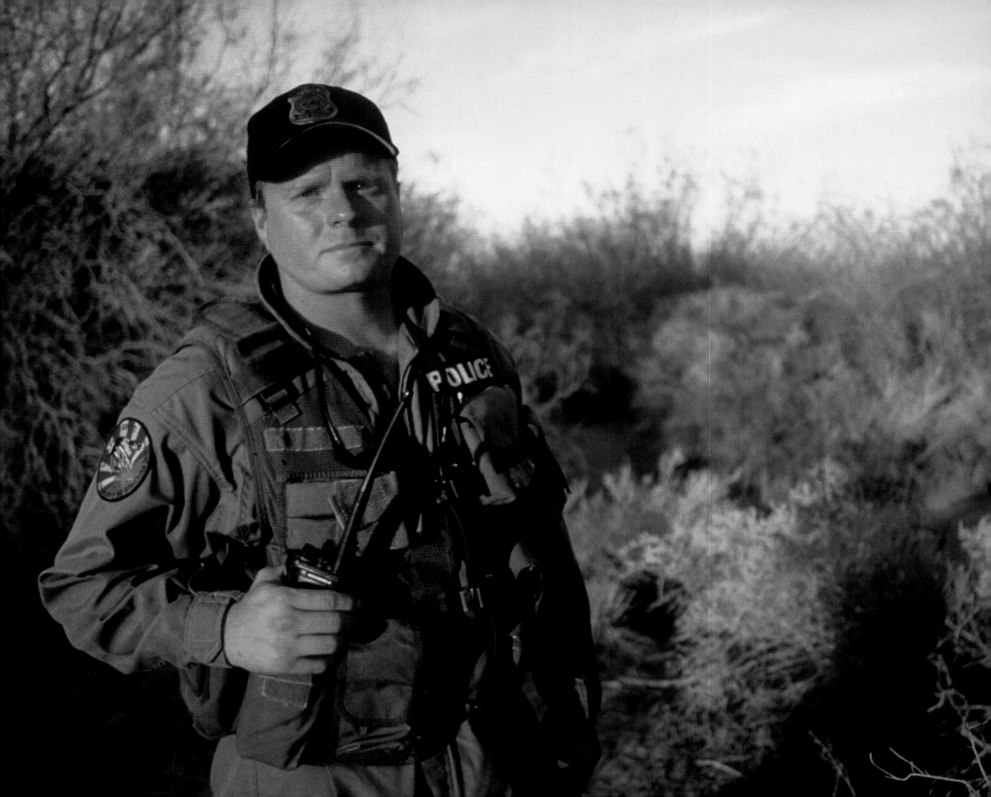

Drug scout lookout, Organ Pipe. These confiscated cell phones, radios, and walkie-talkies were used by drug scouts, who also utilize night-vision goggles, encrypted radios, police scanners, and portable transmitters atop remote counter-surveillance LPOPs (Listening Posts/Observation Posts) that stretch 100 miles across desert from the Mexican border to Interstate 8. (OPPOSITE) *Murder scene, Organ Pipe. Law Enforcement Ranger Jon Young stands at the spot where his friend, Ranger Kris Eggle, was murdered on August 9, 2002.*

Smugglers' trail, No Name Pass. Tracking two days earlier, Ranger Bo Stone "cut sign" of another group of smugglers headed for No Name Pass. (OPPOSITE) *Abandoned drug loads, No Name Pass, Organ Pipe. Three twenty-kilo backpack loads of marijuana lay abandoned, along with a thirty-kilo backpack filled with five days' worth of canned food for the hundred-mile trek to Interstate 8.*

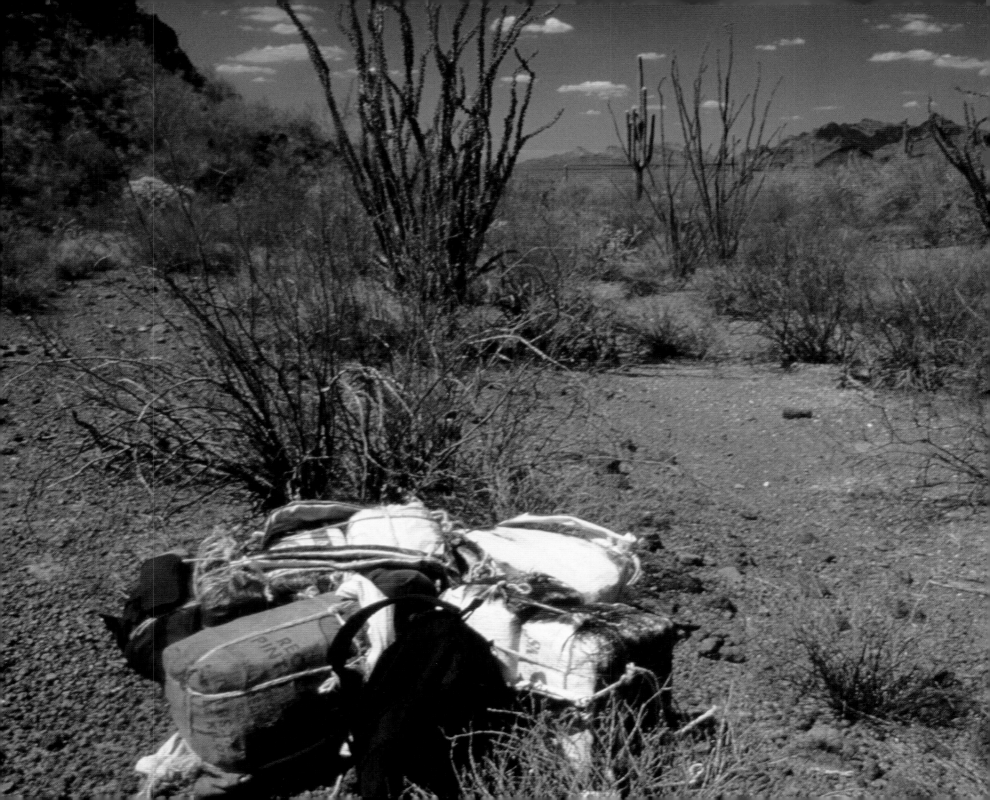

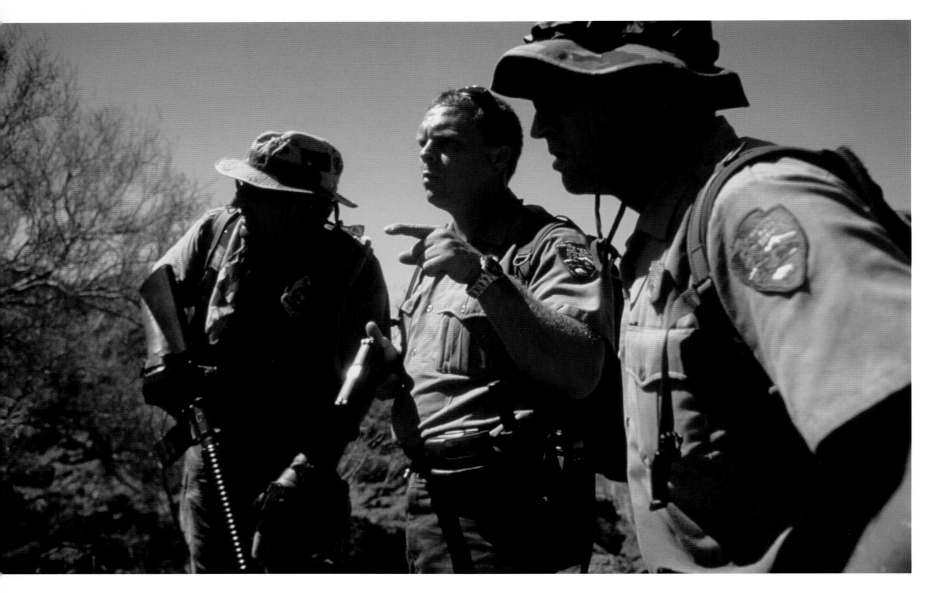

Locked and loaded, No Name Pass. Detecting movement in a mesquite thicket, National Park Rangers (left to right) Joel Ellis, Jon Young, and Joseph Cook spot the drug mules' hideout. (OPPOSITE) *Apprehension, No Name Pass. Two suspected drug mules sit handcuffed in the summer heat, while Customs and Border Protection agents organize a search for eight to ten other suspects who'd fled on foot toward Mexico.*

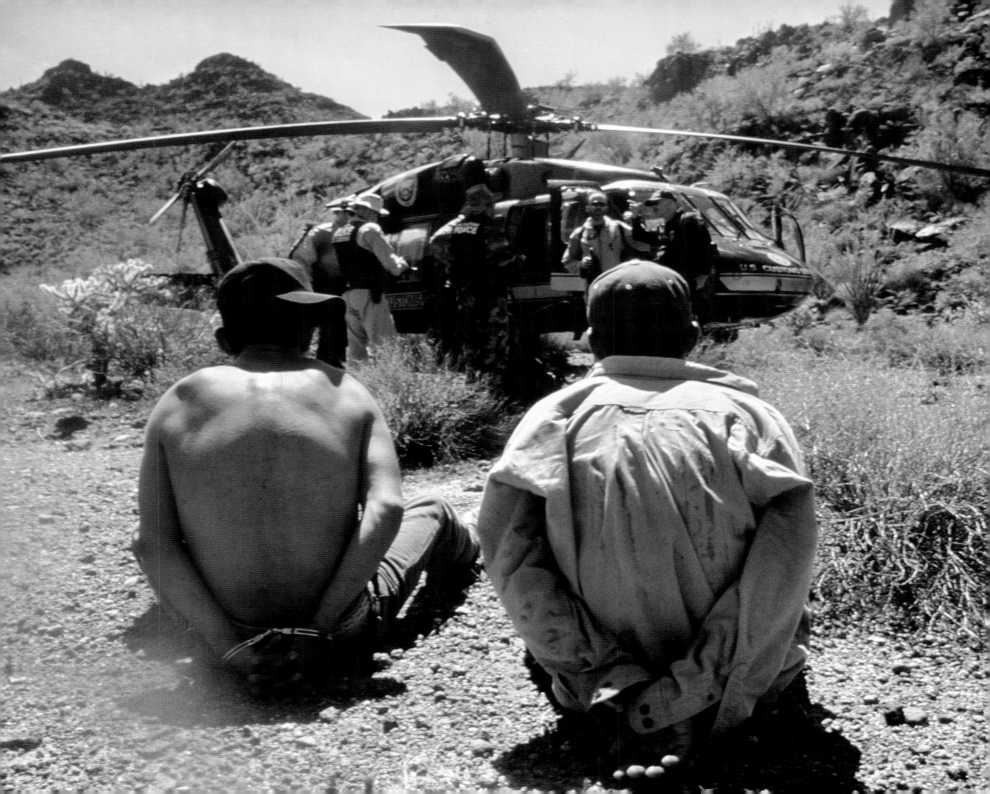

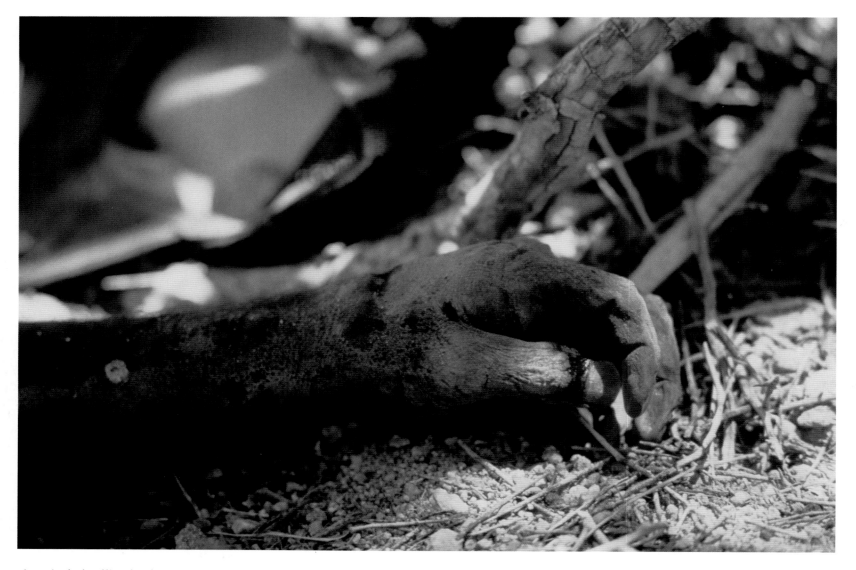

America's deadliest border crossing, Arizona. The hand of a deceased migrant is a grim reminder of the more than 4,100 people who have died crossing America's desert borderlands since the Border Patrol launched Operation Gate Keeper in 1994. (OPPOSITE) *World's busiest border crossing, Tijuana, Baja California Norte and San Isidro, California. Each day some thirty-five thousand cars and thirty thousand pedestrians cross the Tijuana and San Diego Port of Entry.*

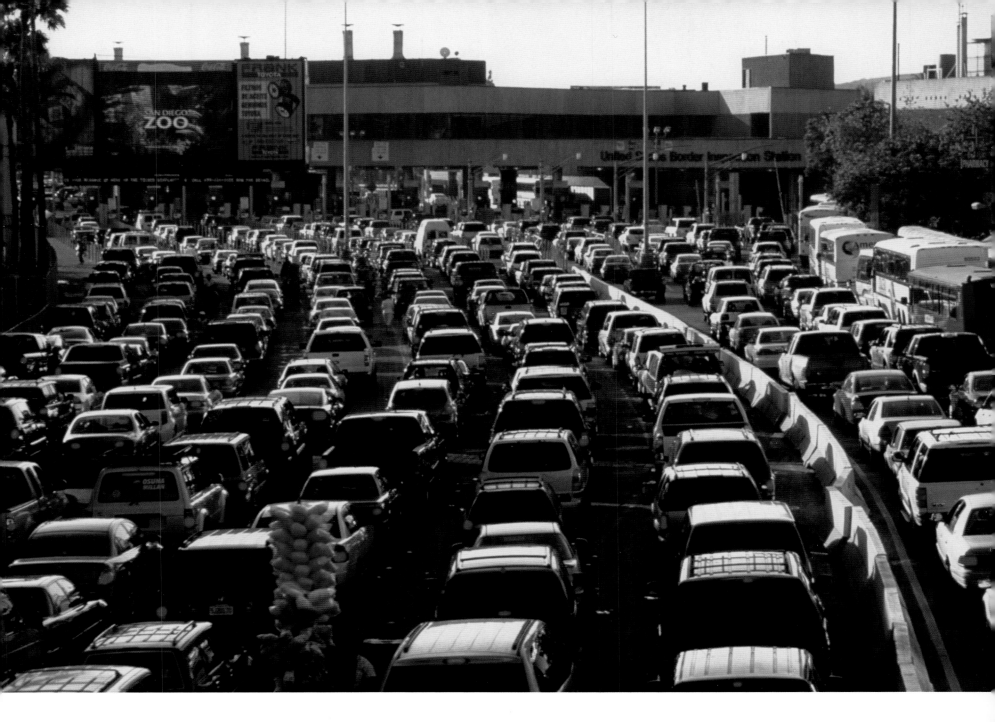

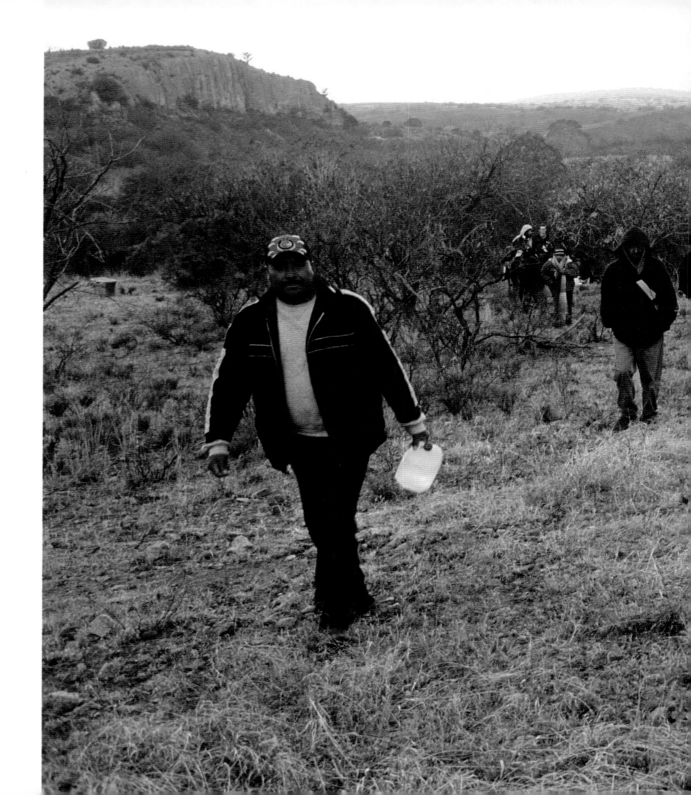

Using homemade wooden ladders, steel bracing, tree limbs, and rope lassoes, The Wall—as this goes to press—has not stemmed the mass exodus of immigrants fleeing Mexico for a better life in America. Under the cover of darkness, immigrants cross the borderlands near their pickup point in the Arizona desert.

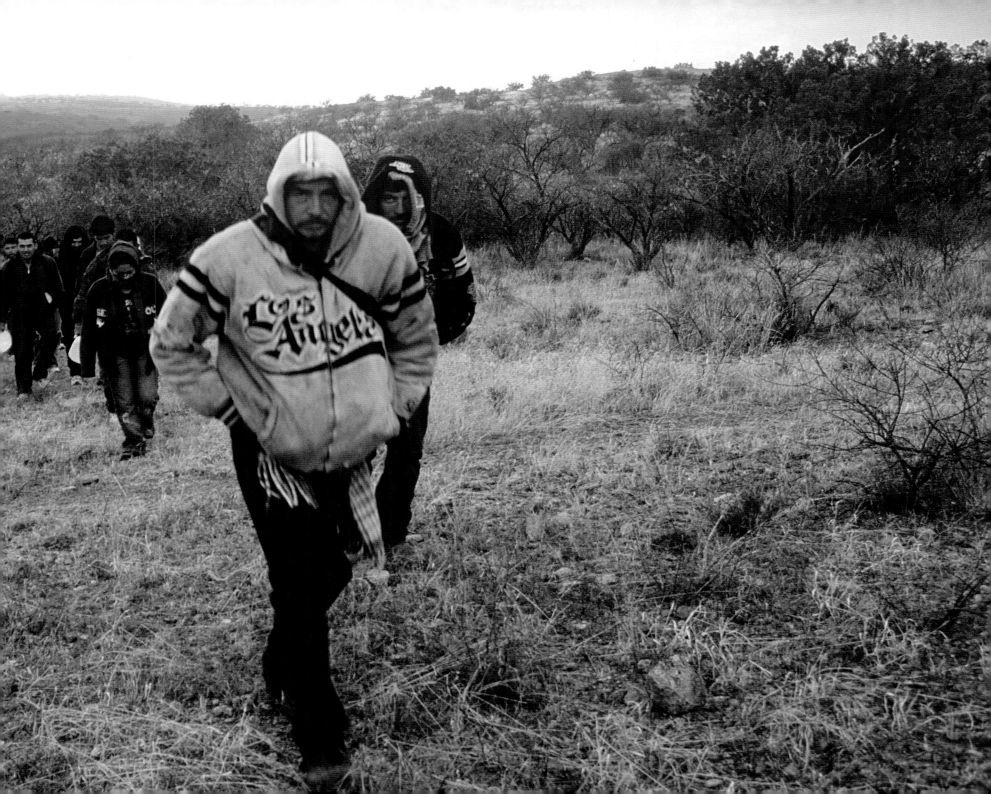

Abbey, Edward. *Cactus Country. The American Wilderness* series. New York: Time-Life Books, 1973.

Ágreda, María de Jesús de. *Mistica Ciudad de Dios y Biografiá de su Autora*, Vol. V. Barcelona, Spain: Heredos de Juan Gil, Editores, 1914.

Annerino, John. The Virgin of Guadalupe/*La Virgen de Guadalupe* (photographs by the author). San Mateo, CA: Browntrout Publishers, 2008.

———. *Indian Country: Sacred Ground, Native People* (photographs by the author).Woodstock, VT: Countryman Press, 2007.

———. *Desert Light: A Photographer's Journey through America's Desert Southwest* (photographs by the author). *Woodstock, VT: Countryman Press, 2006.*

———. *Dead in Their Tracks: Crossing America's Desert Borderlands* (photographs and maps by the author). New York: Four Walls Eight Windows, 1999. Paperback edition 2003. New 3rd edition University of Arizona Press, 2009.

———. *The Wild Country of Mexico / La tierra salvaje de México* (photographs by the author), trans. Silvio Sirias. San Francisco: Sierra Club Books, 1994.

———. *Canyons of the Southwest: A Tour of the Great Canyon Country from Colorado to Northern Mexico* (photographs by the author). San Francisco: Sierra Club Books, 1993. Paper edition University of Arizona Press, 2000.

———. "The Original Cowboys: *Los Charros*" (photo essay by the author). *Phoenix Magazine,* vol. 29, no. 5 (May 1994): 76–81.

———. *El Camino del Diablo* in *Adventuring in Arizona*. 19–39. San Francisco: Sierra Club Books, 1991. Revised 2nd edition, 1996. Revised 3rd edition University of Arizona Press, 2003.

Anonymous author, Tucson, Arizona, personal communication, 2007.

Anonymous Special Forces veteran, Tucson, personal communication, 2006.

Anonymous SWAT commander, Tucson, personal communication, 1997.

Anonymous U.S. Custom's Blackhawk pilot, U.S.–Mexico border, Arizona, personal communication, d. n.a.

"Atención Gringo. For Gold & Glory, Come South of the Border . . ." Chihuahua, Mexico, recruitment poster, January 1915.

Barnes, Will C., and Byrd H. Granger. *Arizona Place Names* (illustrated by Anne Merriman Peck). Tucson: University of Arizona Press, 1979.

Bolton, Herbert Eugene. *Spanish Exploration in the Southwest: 1542–1706*. New York: Charles Scribner's Sons, 1916.

———. *Anza's California Expeditions*. Berkeley: University of California Press, 1930.

———. *Kino's Historical Memoir of Pimería Alta*. 2 vols. Berkeley: University of California Press, 1948.

Bones, Jim. *Rio Grande: River to the Sea* (photographs by the author). Austin: Texas Monthly Press, 1985.

Bowden, Charles. *Killing the Hidden Waters*. Austin: University of Texas Press, 1977; reissued 1992.

Brandes, Ray, and Ralph A. Smith. "The Scalp Business on the Border, 1837–1850: Accounts of the 'Hair Raising' Exploits of Two of History's Bloodiest Barbers, Kirker and Glanton" (map by Don Bufkin). Tucson Westerners, *The Smoke Signal,* no. 6 (fall 1962): 116.

Brown, David E., and Carlos A. López González. *Borderland Jaguars/ Tigres de la Frontera*. Salt Lake City: University of Utah Press, 2001.

Broyles, Bill, ed. "Science on Desert and Lava: A Pinacate Centennial," parts I & II. *Journal of the Southwest*, vol. 49, nos. 2 & 3 (summer, autumn 2007): 129–321, 322–504.

Broyles, Bill, and Richard S. Felger, eds. *Dry Borders: Great Natural Reserves of the Sonoran Desert*. Salt Lake City: University of Utah Press, 2007.

Bureau of Land Management. *La Cueva Trail Guide* BLM-NM-GI-98-008-1230.

Cano, Tony, and Ann Sochat. *Bandido: The True Story of Chico Cano, the Last Western Bandit*. Canutillo, TX: Reata Publishing, 1997.

Carmony, Neil B. and David E. Brown, eds. *Mexican Game Trails: Americans Afield in OldMexico, 1866–1940*. Norman: University of Oklahoma Press, 1991.

———. *The Wilderness of the Southwest: Charles Sheldon's Quest for Desert Bighorn Sheep and Adventures with the Havasupai and Seri Indians*. Salt Lake City: University of Utah Press, 1993.

Castañeda, Carlos. *The Teachings of Don Juan: A Yaqui Way of Knowledge*. New York: Pocket Books, 1974.

Chávez, Octovio. *La Charrería: Tradición Mexicana*. México: Instituto Mexiquense de Cultura, 1991.

Colahan, Clark A. *The Visions of Sor María de Ágreda: Writing Knowledge and Power*. Tucson: University of Arizona Press, 1994.

Crouch, Brodie. *Jornada del Muerto: A Pageant of the Desert*. Spokane, WA: Arthur H. Clarke, 1989.

Daniels, George G., editor. *The Spanish West*. The Old West series. Alexandria, VA: Time-Life Books, 1976.

Debo, Angie. *Geronimo: The Man, His Time, His Place*. Norman: University of Oklahoma Press, 1976.

DiRosa, Roger. Refuge Manager, Cabeza Prieta National Wildlife Refuge, Ajo, Arizona, personal communication, 2007.

Emory, William H. *Report on the United States and Mexico Boundary Survey*, vol. I, 34th Congress, 1st Session. House of Representatives, ex. doc. no. 135. Washington, DC: Cornelius Wendell, Printer: 1857.

Fontana, Bernard L. *Entrada: The Legacy of Spain and Mexico in the United States*. Tucson, AZ: Southwest Parks and Monuments Association, 1994.

Forbes, R. H. *Crabb's Filibustering Expedition into Sonora, 1857*. Tucson: Arizona Silhouettes, 1952.

Fuentes, Carlos. *The Old Gringo*. New York: Farrar, Straus and Giroux, 1985.

Gaillard, Captain David D. "The Perils and Wonders of a True Desert," *Cosmopolitan*, vol. 21, no. 6 (October 1896): 592–605.

Glenn, Warner. *Eyes of Fire: Encounter with a Borderlands Jaguar* (photographs by the author). El Paso, TX: Printing Corner Press, 1996.

Hallenbeck, Cleve. *Álvar Núñez Cabeza de Vaca: The Journey and Route of the First European to Cross the Continent of North America, 1530–1536* (maps by the author). Glendale, CA: Arthur H. Clark Co., 1940.

Hallenbeck, Cleve, and Juanita H. Williams. *Legends of the Spanish Southwest*. Glendale, CA: Arthur H. Clarke, 1938.

Hartmann, William K. *Desert Heart: Chronicles of the Sonoran Desert* (photographs and map by the author). Tucson: Fisher Books, 1989.

Heald, Weldon F. "Mountains in the Sun." *Arizona Highways*, vol. 35, no. 10 (October 1959): pps. 28–35.

Horgan, Paul. *Great River: The Rio Grande in North American History*. 2 vols. New York: Rinehart & Company, 1954.

Hornaday, William T. *Camp-Fires on Desert and Lava* (photographs by the author and others, map by Godfrey Sykes). New York: Charles Scribner's Sons, 1908; reissued by University of Arizona Press, 1983.

International Boundary Commission. *Report on the Survey and the Re-Marking of the Boundary between the United States and Mexico West of the Rio Grande, 1891–1896*. Senate Document No. 47, 55th Congress, 2nd Session, 1898. Vol. II: 26.

Ives, Ronald D. *Land of Lava, Ash and Sand: The Pinacate Region of Northwestern Mexico* (maps by the author and Don Bufkin). Tucson: Arizona Historical Society, 1989.

Jackson, H. Joaquin, and David Marion Wilkinson. *One Ranger, A Memoir*. Austin: University of Texas Press, 2005.

Leopold, A. Starker. *Wildlife of Mexico: The Game Birds and Mammals,* (illustrated by Charles W. Schwartz). Berkeley: University of California Press, 1959.

Lumholtz, Carl. *New Trails in Mexico: An Account of One Year's Exploration in North-Western Sonora, Mexico, and South-Western Arizona 1909–1910*. New York: Charles Scribner's Sons, 1912; reissued by The Southwest Center / University of Arizona Press, 1990.

Mogenthaler, Jefferson. *The River Has Never Divided Us: A Border History of La Junta de los Ríos*. Austin: University of Texas Press, 2004.

Morris, Roy, Jr. *Ambrose Bierce: Alone in Bad Company*. New York: Oxford University Press, 1999.

Nabhan, Gary, et al. "A Meager Living on Lava and Sand? Hia Ced O'odham Food Resources and Habitat Diversity in Oral and Documentary Histories." *Journal of the Southwest,* vol. 31, no. 4 (winter 1989): 508–533.

National Park Service, U.S. Department of the Interior. *Chiricahua National Monument, Arizona*. GPO: 2006-320-369/00460.

Neruda, Pablo. *Fulgar y Muerte de Joaquín Murieta / Splendor and Death of Joaquin Murieta*, trans. Ben Belitt. New York: Farrar, Straus and Giroux, 1972.

Ortiz, Alfonso, ed. *Handbook of North American Indians: Southwest,* vol. 10. Washington, DC: Smithsonian Institution, 1983.

Peacock, Doug. *Walking it Off: A Veteran's Chronicle of War and Wilderness*. Cheney: Eastern Washington University Press, 2005.

Perkins, Clifford Alan. *Border Patrol: With the U.S. Immigration Service on the Mexican Boundary 1910–1954* (photographs by W. D. Smithers). El Paso: Texas Western Press, 1978.

Poppa, Terrence E. *Drug Lord: The Life and Death of a Mexican Kingpin*. New York: Pharos Books, 1990.

Rak, Mary Kidder. *Border Patrol*. Boston: Hougton Mifflin, Co., 1938.

Reed, John. *Insurgent Mexico*. New York: London, D. Appleton & Co., 1914.

Richardson, Sam. "*Su Familia, Su Tierra, Su Hogar:* Chico Cano Fought for Family, Land, Home." *The Big Bend Gazette,* vol.6, no.2 (February 1, 2006): 6.

Rojas, Manuel. *Joaquín Murrieta, El Patrio: el "Far West" del Mexico Cercenado*. Mexicali, B.C., Mexico: Gobierno del Estado de Baja California, 1986

Rodríguez, Theresa, Diane Montané, Lisa Pulitzer, (contributor). *The Daughters of Juárez: A True Story of Serial Murder South of the Border*. New York: Atria, 2007.

Salas, Elizabeth. *Soldaderas in the Mexican Military: Myth and History*. Austin: University of Texas Press, 1990.

Shannon, Elaine. *Desperadoes: Latin Drug Lords, U.S. Lawmen, and the War America Can't Win.* New York: Signet, 1991. First published in 1988 by Penguin.

Sierra-Páramo, Natalia. Guanajuato, Mexico, personal communication, 2000.

Smith, Ralph A. *Borderlander: The Life of James Kirker. 1793–1852.* Norman: University of Oklahoma Press, 2000.

———. The Scalp Hunter in the Borderlands, 1835–1850" *Arizona and the West,* vol. 6, no. 1 (spring 1964): 5–22.

Smithers, Wilfred Dudley. *Chronicles of the Big Bend: A Photographic Memoir of Life on the Border* (photographs by the author). Austin: Madrona Press, 1976; reissued by Texas State Historical Association, 1999.

Steinbeck, John, and Edward F. Ricketts. *The Log from the Sea of Cortez.* New York: Viking Penguin, 1951.

Traven, B. *The Treasure of the Sierra Madre.* New York: Hill and Wang, 1967.

Tyler, Ronnie C. *The Big Bend: A History of the Last Texas Frontier.* Washington, DC: U.S. Department of the Interior, 1975; reissued by Texas A&M University Press, 1999.

Váldez, Diana Washington. *The Killing Fields: Harvest of Women, The Truth About Mexico's Bloody Border Legacy.* Los Angeles: Peace at the Border, 2007.

Walker, Henry P., and Don Bufkin. *Historical Atlas of Arizona.* Norman: University of Oklahoma Press, 1979.

Wambaugh, Joseph. *Lines and Shadows.* New York: Bantam / Perigord Press,1984.

Wilcove, David S. *No Way Home: The Decline of the World's Great Animal Migrations.* Washington, DC: Island Press, 2007.

Wittliff, Bill. *A Book of Photographs from Lonesome Dove* (photographs by the author, foreword by Larry McMurtry). Austin: University of Texas Press, 2007.

Young, Jon. Law Enforcement Ranger, U.S. Department of Interior, Bureau of Land Management, Phoenix District Office, Arizona, personal communication, 2007.

Zavada, Michael S. "A Mexican Curandera in Arizona." *Desert Plants,* vol., no. 2 (1990): 61–65.

WORLD WIDE WEB

Annerino, John. "Special Report: Dead in Their Tracks." August 2000. *One World Journeys.* www.oneworldjourneys.com /sonoran/exped_report2_a.html.

Anonymous. "The Sonoran Desert." August 2000. *One World Journeys,.* www.oneworldjourneys.com/sonoran/index2.html.

Apollo 14 Image Library. S70-H-538: www.hq.nasa.gov/office/pao /History/alsj/a14/images14.html; S70-34414: www.hq.nasa .gov/alsj/a14/ap14-70-H-538.jpg.

Carroll, Susan. "Border Incursions Rattling Arizonans." *The Arizona Republic,* 3 February 2006. http://arizonacentral.com /arizonarepublic/news/articles/0203incursions0203.html.>

"Chronology—Quarter 3 1970: Athena Re-entry Vehicle Test Mission. Impacted in Mexico." *Encyclopedia Astronautica.* www .astronautix.com/chrono/19703.htm.

Dear, Michael. "Monuments, Manifest Destiny, and Mexico Parts 1 & 2." Summer 2005. *The U.S. National Archives & Records Administration.* www.archives.gov/publications/prologue /2005/summer/mexico-1.html.

Dougherty, Jon. "Kidnapping in Candelaria." December 5, 2003. *WorldNetDaily.* www.worldnetdaily.com/news/article.asp? /ARTICLE__id=35972.

Hernández Memorial Gallery. May 20,1997. www.dpft.org /hernandez/gallery."

Inspector John S.H. (Jack) Howard." *The Officer Down Memorial Page*. www.odmp.org/officer/6737-inspector-john-s.-h.-(jack)-howard.

"The Legend of Pavla Blanca." *White Sands National Monument*. www.nps.gov/whsa/legend.html.

"Memorials Database: U.S. Border Patrol Agents Killed in the Line of Duty." *National Border Patrol Museum*. www.borderpatrolmuseum.com/memorials.asp.

Nijhuis, Michele. "Dead End: The Borderlands." September-October 2007 *Audubon Magazine*. http://audubonmagazine.org/features0709/borderlands.html.

Sociedad de Autores y Compositores de Mexico. "Quirino Mendoza y Cortés." www.sacm.org.mx/archivos/biografias.asp?txtSocio=08045.

"Trinity Site." *White Sands Missile Range*. www.wsmr.army.mil/pao/TrinitySite/trinph.htm.

"UFO Files: Mexico's Roswell: The Coyame Crash." *The History Channel*.www.history.com/media.doid=ufofiles_roswell_mexico_broadband&action=clip.

UPI. "Around the World: Border Officers Seeking 3 Men in Agent's Slaying." February 24, 1986. *The New York Times*. http://query.nytimes.com.

Willeford, Glenn. "Ambrose Bierce. "The Old Gringo": Fact, Fiction, and Fantasy." *Ojinaga*. www.ojinaga.com/bierce.

p. 11. "The overriding image at dusk was of shadow." Joseph Wambaugh. *Lines and Shadows*. New York: Bantam/Perigord Press,1984, p. 57.

p. 12. "For God, for glory and for gold." George G. Daniels. *The Spanish West*. The Old West. Alexandria, VA: Time-Life Books, 1976, p. 17.

p. 12. ". . . largest human migration on earth . . ." Anonymous author, Tucson, Arizona, p.c., 2007.

p. 13. "Johnny, we're barely holding the line . . ." Anonymous SWAT commander, Tucson, p.c. 1997.

p. 14. "If I go down, the body armor's . . ." Jon Young, Casa Grande, Arizona, p.c., 2007.

p. 14. "If we go down. . ." Anonymous U.S. Customs Blackhawk pilot, U.S.–Mexico border, Arizona, p.c., d.n.a.

p. 14. "John, the news gets out, but the truth doesn't." Anonymous Special Forces veteran, Tucson, p.c. 2006.

p. 25. "Late in the afternoon of their second day's voyage . . ." Horgan, p. 897.

p. 26. "Su familia, su tierra, su hogar." Sam Richardson. "Su Familia, Su Tierra, Su Hogar: Chico Cano Fought for Family, Land, Home." *The Big Bend Gazette*, vol. 6, no. 2 (February 1, 2006): 6.

p. 26. "Intrigued by rumors of ghosts. . ." Ronnie C. Tyler. *The Big Bend: A History of the Last Texas Frontier*. Washington, DC: U.S. Department of the Interior, 1975, p. 3.

p. 26. ". . .the greenest set of boatmen that ever started down . . ." Charles L. Nevill in Tyler, p. 1.

p. 29. "Atención Gringo. For Gold & Glory, Come South of the Border . . ." Anonymous, January 1915 recruitment poster.

p. 29. "If you hear of my being stood up against . . ." Ambrose Bierce in Glenn Willeford *Ambrose Bierce. "The Old Gringo": Fact, Fiction, and Fantasy*. http://ojinaga.com/bierce/

p. 34. *Photo 20*. Terlingua Abaja Cemetery. "The mine was a silver mine . . ." C. A. Hawley in Ronnie C. Tyler *The Big Bend: A History of the Last Texas Frontier*. Washington, DC: U.S. Department of the Interior, 1975, p.139.

p. 39. "From the mountain ranges, heavenly pretty . . ." Quirino Mendoza y Cortés. *Cielito Lindo,* 1882. *Sociedad de Autores y Compositores de Mexico*.www.sacm.org.mx/archivos/biografias .asp?txtSocio=08045.

p. 51. "Around the camp fires of Mexico there is . . ." A. Starker Leopold. *Wildlife of Mexico*. Berkeley: University of California Press, 1959, ps. 464–465.

p. 52. "Mountains in the Sun." Weldon F. Heald. *Arizona Highways*. vol. 35., no. 10 (October1959): p. 28.

p. 54. ". . . stupendous panorama out over mountains . . ." Heald, p. 28.

p. 54. ". . . lying face down on his crucifix with a knife in his back. . . ." Bureau of Land Management, *La Cueva Trail Guide*, BLM-NM-GI-98-008-1230.

p. 54. *"Ni para mí, ni para el diablo."* Natalia Sierra-Páramo, Guanajuato, Mexico, p.c. 2000.

p. 54. ". . . $75,000 in Mexican silver . . ." Will C. Barnes and Byrd H. Granger. *Arizona Place Names*. Tuscon: University of Arizona Press, 1979, p.52.

p. 57. ". . . miles of magnificent forests . . ." Heald, p. 28.

p. 59. "Land of Standing Up Rocks." National Park Service, U.S. Department of the Interior. *Chiricahua National Monument, Arizona*. GPO: 2006-320-369/00460.

p. 59. ". . . the night remained for two or three hours . . ." A Chiricahua warrior in Angie Debo *Geronimo: The Man, His Time, His Place*. Norman: University of Oklahoma Press, 1976, p. 145.

p. 62. ". . . absolute barrier for all terrestrial wildlife" Christine Hass in Michelle Nijhuis *Dead End: The Borderlands*. September–October 2007. *Audubon Magazine*. http://audubonmagazine.org/features0709/borderlands.html.

p. 62. "For these delectable sky islands . . ." Heald, p. 35.

p. 77. "Another phenomena peculiar to the desert . . . is the mirage." Captain David D. Gaillard. "The Perils and Wonders of a True Desert," *Cosmopolitan,* vol. 21, no. 6 (October 1896): p. 598.

p. 84. ". . . a record probably without parallel in North America . . ." International Boundary Commission. *Report on the Survey and the Re-Marking of the Boundary between the United States and Mexico West of the Rio Grande, 1891–1896*. Senate Document No. 47, 55th Congress, 2nd Session, 1898. Vol. II: 26.

p. 85. "Weak and faint, he returned from his unsuccessful search . . ." Gaillard, p. 603.

p. 85. "Many made the dreaded journey in safety . . ." Gaillard, p. 602.

p. 85. "Off in the distance . . ." Edward Abbey. *Cactus Country.* The American Wilderness series. New York: Time-Life Books, 1973, pps. 22–23.

p. 85. ". . . the last great treasure in the Continental United States . . ." Anonymous. "The Sonoran Desert." August 2000. *One World Journeys*. .www.oneworldjourneys.com/sonoran/index2.html.

p. 88. ". . . the greatest transnational biological reserve on earth . . ." Anonymous. The Sonoran Desert.

p. 90. *Photo 72*. Under Siege. ". . . ten circling buzzards . . ." Doug Peacock. *Walking it Off: A Veteran's Chronicle of War and Wilderness*. Cheney, WA: Eastern Washington University Press, 2005, p. 48.

p. 93. *"¡Todo o Nada!"* ("Everything or Nothing!") Joaquin Murrieta in Manuel Rojas. *Joaquin Murrieta, El Patrio: el "Far West" del México Cercenado*. Mexicali, B.C., México: Gobierno del Estado de Baja California, 1986, p. 50.

p. 93. "Yet, in spite of all that has been said . . ." Gaillard, p. 605.

p. 98. *Photo 78*. Sea of Cortés. ". . . literally scraping the bottom clean . . ." John Steinbeck, *The Log from the Sea of Cortez*. New York: Viking Penguin, 1951, p. 294.

p. 105. Afterword. "What's going to have to happen?" Camarena said miserably." Elaine Shannon, *Desperadoes: Latin Drug Lords, U.S. Lawmen, and the War America Can't Win*. New York: Penguin, 1988; Signet, 1991, p. 229.

p. 106. ". . . thirty to fifty Mexican police, Federales, and PJF . . . shooting over the fence . . ." Jon Young, p.c., 2007.

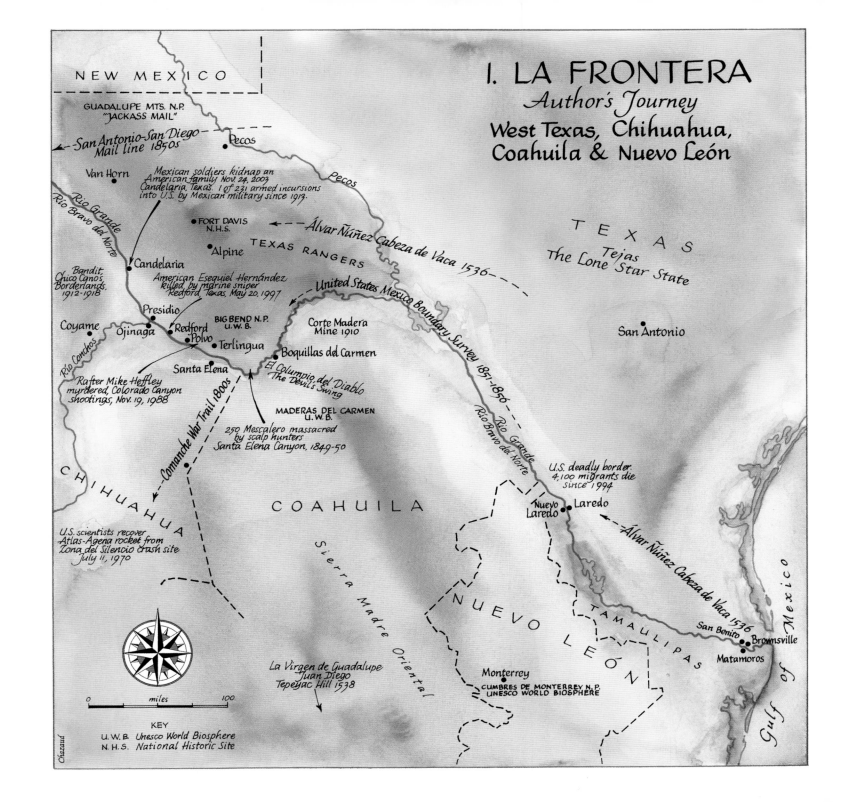

I. LA FRONTERA
Author's Journey
West Texas, Chihuahua, Coahuila & Nuevo León

NEW MEXICO

GUADALUPE MTS. N.P.
"JACKASS MAIL"

San Antonio-San Diego
Mail line 1850s

Pecos

Van Horn

Mexican soldiers kidnap an
American family Nov. 24, 2003
Candelaria, Texas. 1 of 231 armed incursions
into U.S. by Mexican military since 1913.

Pecos

T E X A S

Tejas
The Lone Star State

FORT DAVIS
N.H.S.

Álvar Núñez Cabeza de Vaca 1536

Rio Grande
Rio Bravo del Norte

Alpine

TEXAS RANGERS

Candelaria

Bandit
Chico Cano's
Borderlands,
1912-1918

American Esequiel Hernández
killed by marine sniper
Redford, Texas, May 20, 1997

United States Mexico Boundary Survey 1851-1856

San Antonio

Presidio

Coyame

BIG BEND N.P.
U.W.B.

Corte Madera
Mine 1910

Ojinaga Redford
Polvo

Rio Conchos

Terlingua

Boquillas del Carmen

Santa Elena

El Columpio del Diablo
The Devil's Swing

Rafter Mike Heffley
murdered, Colorado Canyon
shootings, Nov. 19, 1988

Comanche War Trail 1800s

MADERAS DEL CARMEN
U.W.B.

250 Mescalero massacred
by scalp hunters
Santa Elena Canyon, 1849-50

C H I H U A H U A

U.S. deadly border:
4,100 migrants die
since 1994

U.S. scientists recover
Atlas-Agena rocket from
Zona del Silencio crash site
July 11, 1970

C O A H U I L A

Rio Grande
Rio Bravo del Norte

Nuevo
Laredo Laredo

Álvar Núñez Cabeza de Vaca 1536

Sierra Madre Oriental

N U E V O L E Ó N

TAMAULIPAS

San Benito
Brownsville

Matamoros

Gulf of Mexico

La Virgen de Guadalupe
Juan Diego
Tepeyac Hill 1538

Monterrey

CUMBRES DE MONTERREY N.P.
UNESCO WORLD BIOSPHERE

0 miles 100

KEY
U.W.B. Unesco World Biosphere
N.H.S. National Historic Site

Chazaud

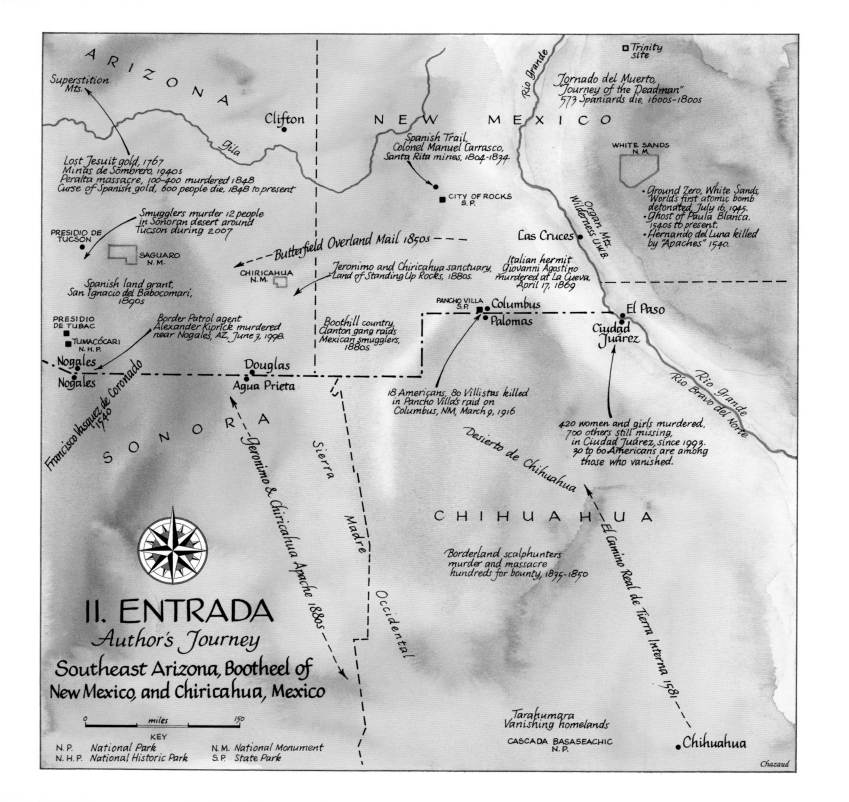

ARIZONA

Superstition Mts.

Clifton

NEW MEXICO

Gila

□ Trinity site

Rio Grande

Jornado del Muerto, "Journey of the Deadman" 573 Spaniards die, 1600s-1800s

Lost Jesuit gold, 1767
Minas de Sombrero, 1940s
Peralta massacre, 100-400 murdered 1848
Curse of Spanish gold, 600 people die, 1848 to present

Spanish Trail, Colonel Manuel Carrasco, Santa Rita mines, 1804-1834

CITY OF ROCKS S.P.

WHITE SANDS N.M.

• Ground Zero, White Sands, World's first atomic bomb detonated, July 16, 1945.
• Ghost of Paula Blanca, 1540s to present.
• Hernando del Luna killed by "Apaches" 1540.

Smugglers murder 12 people in Sonoran desert around Tucson during 2007

PRESIDIO DE TUCSON

SAGUARO N.M.

Butterfield Overland Mail 1850s

CHIRICAHUA N.M.

Jeronimo and Chiricahua sanctuary, Land of Standing Up Rocks, 1880s.

Las Cruces

Organ Mts. Wilderness U.W.B.

Italian hermit Giovanni Agostino murdered at La Cueva, April 17, 1869

Spanish land grant, San Ignacio del Babocomari, 1890s

PRESIDIO DE TUBAC

TUMACÓCARI N.H.P.

Border Patrol agent Alexander Kiprick murdered near Nogales, AZ, June 3, 1998.

Boothill country, Clanton gang raids Mexican smugglers, 1880s

PANCHO VILLA S.P.

Columbus
Palomas

El Paso

Ciudad Juárez

Nogales
Nogales

Douglas

Agua Prieta

Francisco Vasquez de Coronado 1540

SONORA

18 Americans, 80 Villistas killed in Pancho Villa's raid on Columbus, NM, March 9, 1916

Rio Grande

Rio Bravo del Norte

420 women and girls murdered, 700 others still missing, in Ciudad Juárez, since 1993. 30 to 60 Americans are among those who vanished.

Jeronimo & Chiricahua Apache 1880s

Sierra Madre Occidental

Desierto de Chihuahua

CHIHUAHUA

Borderland scalphunters murder and massacre hundreds for bounty, 1835-1850

El Camino Real de Tierra Interna 1581

II. ENTRADA
Author's Journey
Southeast Arizona, Bootheel of New Mexico, and Chiricahua, Mexico

Tarahumara Vanishing homelands

CASCADA BASASEACHIC N.P.

• Chihuahua

0 — miles — 150

KEY
N.P. National Park
N.H.P. National Historic Park
N.M. National Monument
S.P. State Park

Chazaud

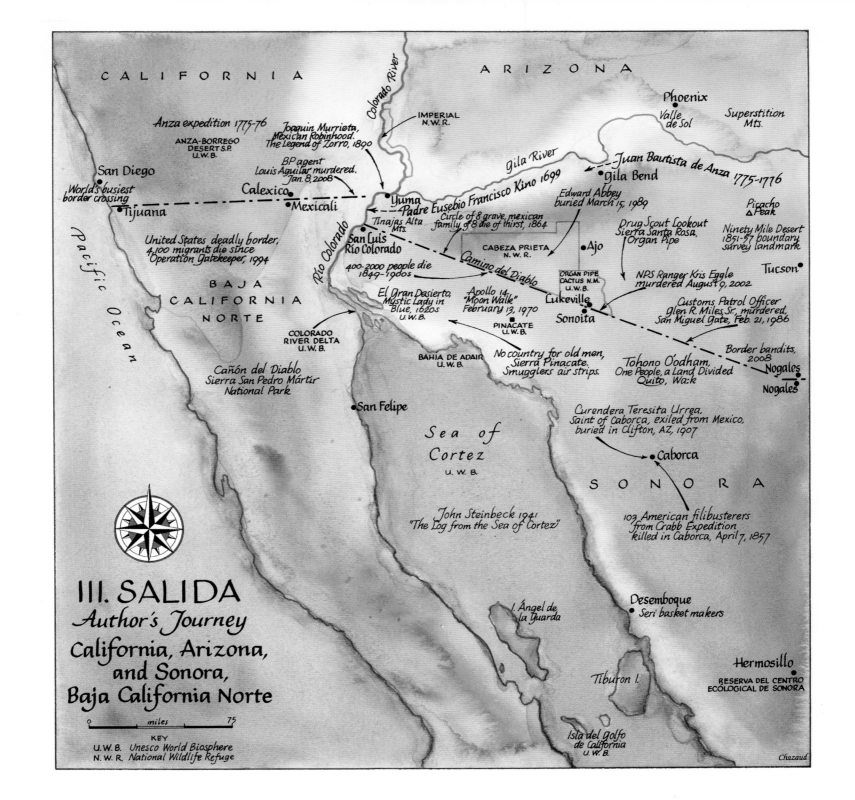

Undercover Agent Joe Parra Berumi, undisclosed location. The retired Interpol agent survived a bloody forty-year war on drugs, working deep cover behind the lines from the mountains of Columbia and Mexico, across the borderlands to the mean streets of America.